Tradition and Renewal: Contemporary Art in the German Democratic Republic

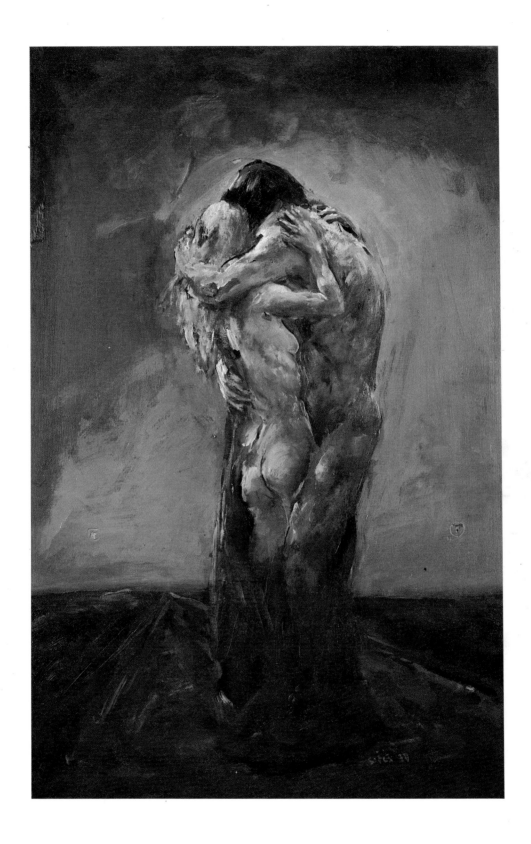

Sighard Gille:
Study for 'Ferry' 1977
No.34

Tradition
CONTEMPORARY ART

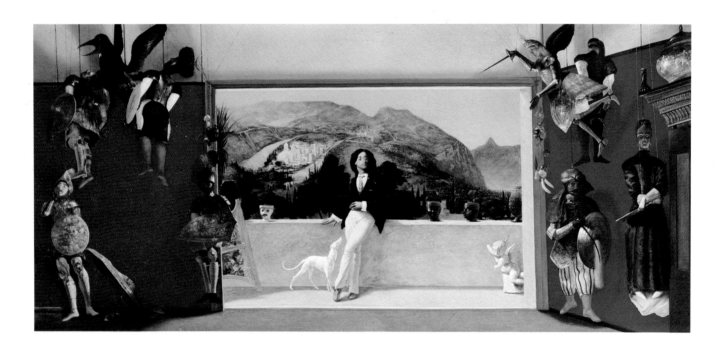

Werner Tübke:
Sicilian Estate Owner with Puppets 1972
No.112

and Renewal:
N THE GERMAN DEMOCRATIC REPUBLIC

An exhibition organised by
The Museum of Modern Art, Oxford
and the Ministry of Culture of the German Democratic Republic
1984

In 1981 I was asked by Willi Lange, the Cultural Attaché of the German Democratic Republic Embassy in London whether I would be interested in selecting and showing at the Museum an exhibition of contemporary art from the GDR. It was difficult at that time to give an answer as no exhibition had been seen in the UK and my knowledge of this work rested upon a large Willi Sitte retrospective I had visited in Moscow and upon the few general catalogues that had found their way into the Museum's library. To pursue the project further it was necessary to visit the GDR, visit studios and see at first hand what artists were doing.

An invitation was issued by the Ministry of Culture the following year to visit the National Art Exhibition which takes place every four years in Dresden. I accepted and all initial arrangements for the visit were made by the British Council. The IX National Art Exhibition was a vast and comprehensive survey of Art and Design and this provided an invaluable starting point for the series of studio and museum visits upon which this selection was based. I was left in no doubt that an exhibition should be made.

A large number of people have helped in the organisation of this exhibition and I should like to take this opportunity of thanking them. The project was helpfully and efficiently supervised at the Ministry of Culture by Elizabeth Grigull of the Foreign Relations Department. Gabriele Wittrin of the Centre for Art Exhibitions kindly undertook the negotiation of loans and the preparation of catalogue material. Eva Tosch, Eva Eissmann and Doris Schneider all greatly helped in the planning of my visits. Graham Coe, cultural attaché at the British Embassy in East Berlin and Georges Menzel, present GDR cultural attaché in London were also helpful in providing assistance and advice.

I should also like to thank the artists, private collectors, museums and galleries who could not have been more generous in lending their work and allowing it to travel.

Lastly I should like to make special acknowledgement of the financial assistance of the Visiting Arts Unit of Great Britain which has been of particular help in bringing this exhibition on tour throughout Britain.

David Elliott
Director, Museum of Modern Art, Oxford

Contents

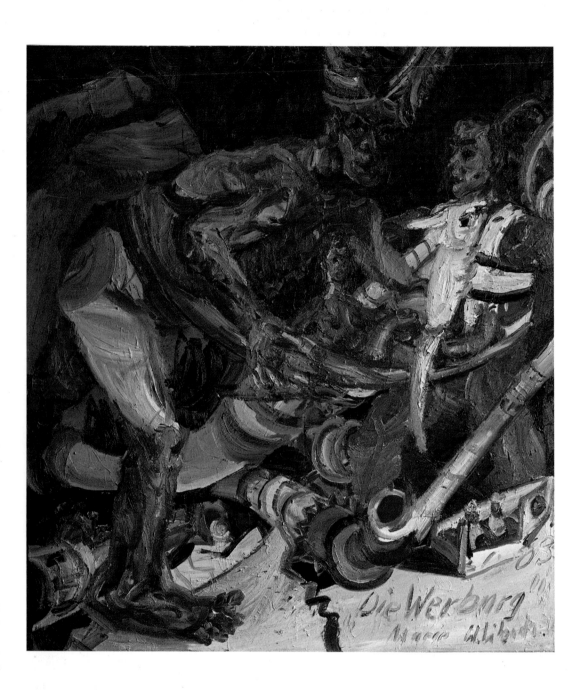

Walter Libuda:
The Courtship IV (**Marie**) 1983
No.62

David Elliott:

REFLECTOR AND DYNAMO

The position of artists in the German Democratic
Republic differs markedly from that of their counter-
parts in the West in that they are regarded as a
generating force for social change. As both reflector and
dynamo their responsibility is to mirror and inspire the
development of society and the needs of the people. To
do this their work must be broadly intelligible; this can
provide a challenge to open up new possibilities and, as
is clear from the work shown here, does not result in a
facile popularism.

Artists are often asked to participate in large public
commissions and the art of mural painting is at present
undergoing a widespread and vigorous revival. One of
the most impressive of these is the panorama, 123
metres long by 14.5 metres high on the history of the
Reformation and Peasant Wars which Werner Tübke
has recently completed for a new Memorial Museum in
Bad Frankenhausen. This is rivalled by the large mural,
three stories high, entitled 'Song of the Earth', which
Sighard Gille has recently executed for the new concert
hall in Leipzig. Yet not all such work is public, painting
on walls seems to run in these artists' blood; one of the
most striking impressions I was to retain from my
travels throughout the country was that of the enigmatic
and strongly-brushed figures which covered every
surface in the dark hallway of Walter Libuda's top floor
Leipzig tenement.

For obvious reasons such large scale murals cannot
be shown here although related studies have been
included. This exhibition is confined to paintings and
graphic work by fifteen leading contemporary artists.
While it does not provide a comprehensive survey, and
makes no claim to do so, it does illustrate those
distinctive attitudes which run throughout the work of
three generations. The title, *Tradition and Renewal*,
refers to the way in which artistic and cultural traditions

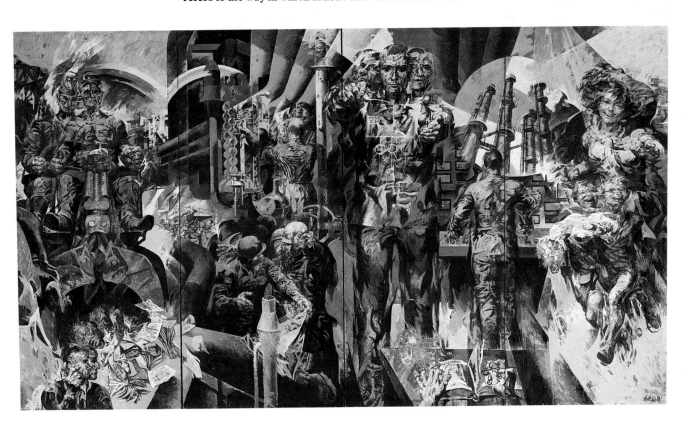

Willi Sitte:
Leuna 1969
Mixed media
Nationalgalerie, Berlin
Not in exhibition

are brought together with the urge and necessity to innovate. This tendency can be distinguished throughout in spite of the considerable diversity of work shown. Such a concern with the art of the past bears an unexpected similarity to recent developments in the West where a dialogue with traditional forms of representation has now begun to undermine the naively progressive basis of much modernist art.

All of the artists here regard themselves as working within the mainstream of a European pictorial tradition which allows reference to the work of Cranach or Rubens as easily and as logically as it does to that of closer precursors such as Lovis Corinth, Otto Dix or Max Beckmann. This connection with the past was made not without difficulty. During the '30s the National Socialists had systematically suppressed the vital traditions of German art in order to propagate a bogus national heritage with a vapid and corrupt classicism. A whole generation of artists had been forced to emigrate, comply or stay without work; those that returned after the war were to find a cultural wasteland where even to speak of a national tradition was to invoke the spectre of Nazism.

Willi Sitte, Bernhard Heisig and Werner Tübke, three of the most senior artists in this exhibition, were all faced with this problem. During the 1950s they became concerned in the reconstruction of a viable national culture and were directly responsible for establishing the latitude within which artists can now work. In doing this, they reacted against the idea that the model of contemporary Soviet Socialist Realism could be appropriated for the art of the new Democratic Republic.

However vital it may once have been, the Soviet model had by this time degenerated into a kind of Socialist Idealism - an automatic and uninspired repetition of worthy workers, jolly tractor drivers and smiling peasants. At its best, worthy, at its worst, kitsch, such work made little attempt to engage with reality. In response, Sitte, Heisig and Tübke looked to other examples, particularly the work of Picasso and Léger in the West who were communists and showed strong social commitment. Receptiveness to this work and to their own traditions was an invaluable catalyst and enabled these artists to redefine actively the role of Socialist Realism within their society. They were able to revalidate it not as a style with recognisable physical attributes and finite duration but as an attitude which gave conviction to art of many different kinds and which could provide a framework of idealogical commitment within which artists could act. In the light of this it does not seem such a contradiction to suggest that history painting in the GDR is really one way of painting the present whether through overt reference to previous political events or by the incorporation of references to the art of previous times.

Wolfgang Petrovsky/Frank Voigt
Cross Above Dresden 1983
No. 76

Werner Tübke often combines such allusions within his paintings, each formal and technical component contributing its own iconographical associations to the poetry of the whole. *Sicilian Estate Owner with Puppets*, 1972, a painting referring to the possession of influence, power and land, is executed characteristically in the *Biedermeier* style of the 1830s and '40s, a time of bourgeois assertiveness.

The use of allegory and montage is widespread amongst artists in the GDR and is related aesthetically to the notion of pictorial dialectic. This is the synthetic use of different or opposed images and materials within one work to make a greater whole.

It is particularly clear in the work of Jürgen Schieferdecker, which molds together components from many different sources, as well as in the silk screen prints of Wolfgang Petrovsky and Frank Voigt. In their strength and immediacy these works transcend any specific political viewpoint to make a statement about universal human values - the ecological horror of industrial pollution, the insanity of nuclear escalation and the legacy of the Holocaust are issues to which they constantly return. In this they are the present heirs to the tradition of committed photomontage handed down from the 1920s and '30s in the work of John Heartfield.

Jürgen Schieferdecker:
Cartography I 'Feuerland' (Tierra del Fuégo)
(continental art no.3) 1977
No.84

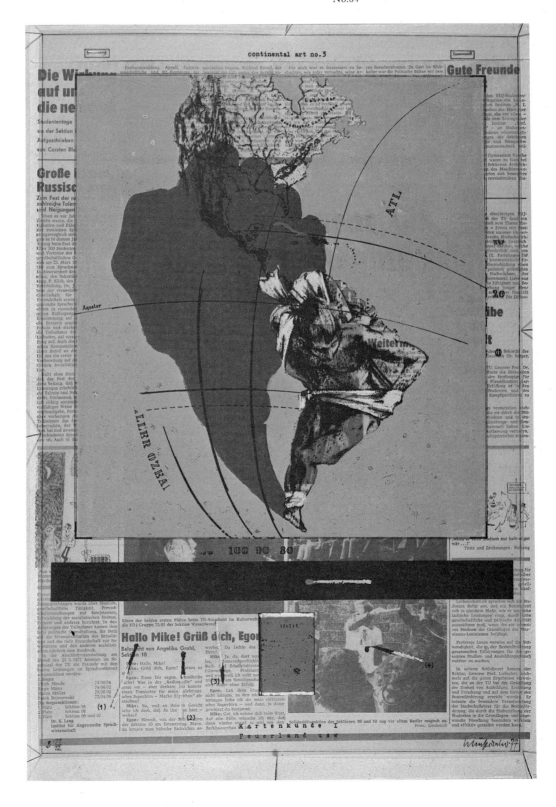

Yet such synthetic use of imagery is not only confined within the bounds of photographic reproduction; it can be seen in the composite paintings of Willi Sitte as in the study for the large triptych *The Red Flag - Struggle, Grief and Victory* as well as in Carlfriedrich Claus' intensely personal etchings which occupy an undefined no-mans' land between the written and the drawn.

The theory of Alienation in the sense used by Bertold Brecht, is also much invoked. Put simply, it is a distancing device which prevents the observer from making an instinctive identification with what has been depicted. This enables the observer to participate in the work by discriminating rationally. A striking if enigmatic, example of the kind of shock tactic which is typical of the use of alienation today, can be seen in Volker Stelzmann's attribution of the features of Adolph Hitler to one of the thieves in *Descent from the Cross*, 1978/79, a painting sadly not available for this exhibition. But it is also clear in the savage irony which is at the root of Bernhard Heisig's historical allegories *Change of Heroes*, 1973 and *The Prime Civil Duty*, 1977 which point back to the moral poverty of Weimar and the triumph of Nazism. Unsettling in a rather different way is Hubertus Giebe's more direct assault on the emptiness and lack of direction of the present: the torrid colour and impassioned brushstrokes of *On 'Isolated Gentleman' (Pablo Neruda) III*, 1982 make this an icon of contemporary alienation - a solitary figure is shown masturbating in front of a naked woman.

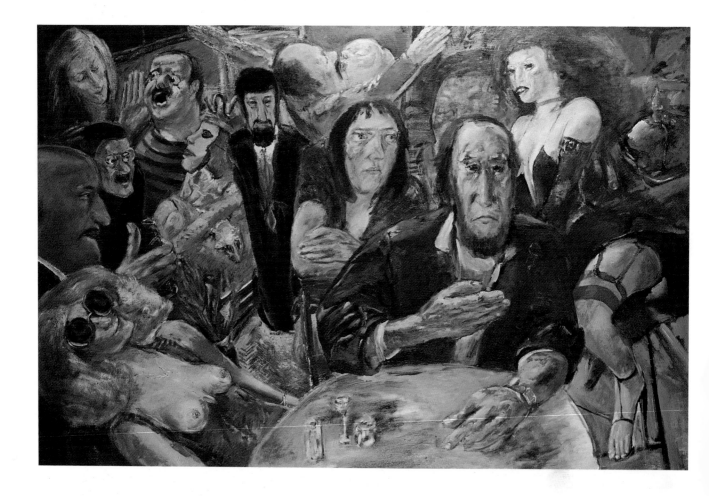

Sighard Gille:
Fête in Leipzig 1979
No.36

A concern with the dynamics of society as a whole does not prevent artists from making more intimate and reflective statements. In the early 1970s Sighard Gille gained a reputation for his unheroic and realistic depiction of worker brigades. But at present his main subject is his family and friends. The two studies for *Ferry* relate to his large mural *Song of the Earth:* two naked lovers embrace oblivious of the pollution in the world around them. *Berlin Studio Window* 1976 also refers to our divided world but in a more literal way: the Berlin Wall and no-man's land stretches out from behind the tense form of the classical torso by the artist's window.

Hartwig Ebersbach is more concerned with the psyche - archetypes, dreams, the conflicts of the subconscious are brought together in an inferno of colour in his paintings. This flux-like energy and sense of transience appears in more concrete form in work by other artists shown here. But it is an energy which is laced with melancholy and despair. The threat of chaos and destruction, never far away, seems particularly close in a world which teeters on the edge of a nuclear abyss. If Bernhard Heisig shows the whole of society engaged in the grim ritual of a dance of death, then Willi Sitte's bleak nudes, Gerhard Kettner's studies of his ageing mother, Dagmar Stoev's penetrating and isolated heads, Gudrun Brüne's heaped, yet uncommunicating figures and Walter Libuda's private and sombre mythologies all give form to a profound individual unease which is sublimated within a personal lyricism and dislocated beauty.

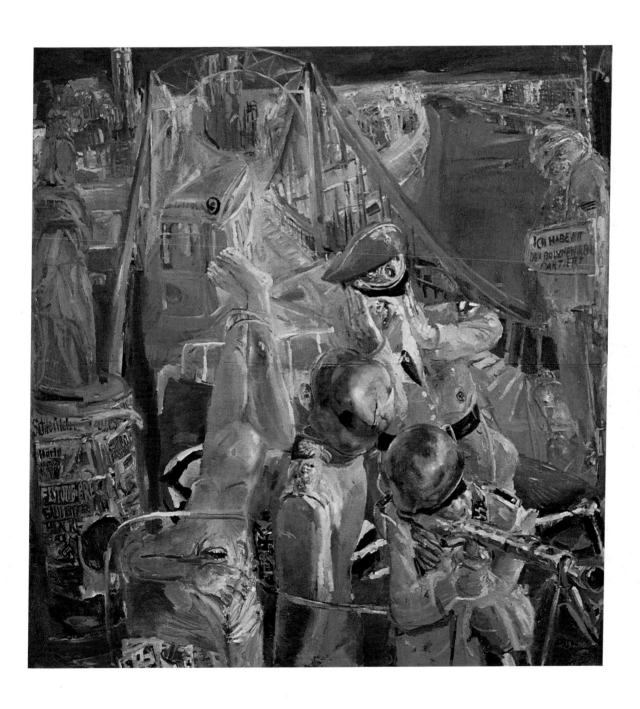

Bernhard Heisig:
Fortress Breslau: The City and Its Murderers 1969
No.46

The ambitious range of subject with which artists engage in the GDR is, no doubt, largely due to the strong emphasis on the acquisition of basic skills which is at the foundation of all Art School training. Admission to the Schools is carefully controlled and within each of the painting departments in the main centres of Berlin, Halle, Leipzig and Dresden there may be no more than thirty students, at any one time, five or six being admitted each year. The complement of students in other departments is, of course, much larger, particularly in the field of design; the large art schools each have a total attendance of betweeen two hundred and fifty and three hundred students.

Competition for admission is, not surprisingly, extremely strong and selection is made by intensive interview and by three-day practical exam. The courses last for five years including a general Foundation Year which, if successfully completed, allows the student to continue to specialise. Generally, teaching in these schools tends to be rather more conservative than in this country with an emphasis laid upon life studies. Experimentation, although allowed by some teachers in the workshops, is not expected in finished work and any tendency towards extreme stylisation or abstraction is discouraged. In addition to practical studies a number of theoretical papers have to be taken: Aesthetics, Art History, Philosophy, *Kulturpolitik*, Political Economy and Scientific Marxism. Together they make a rather

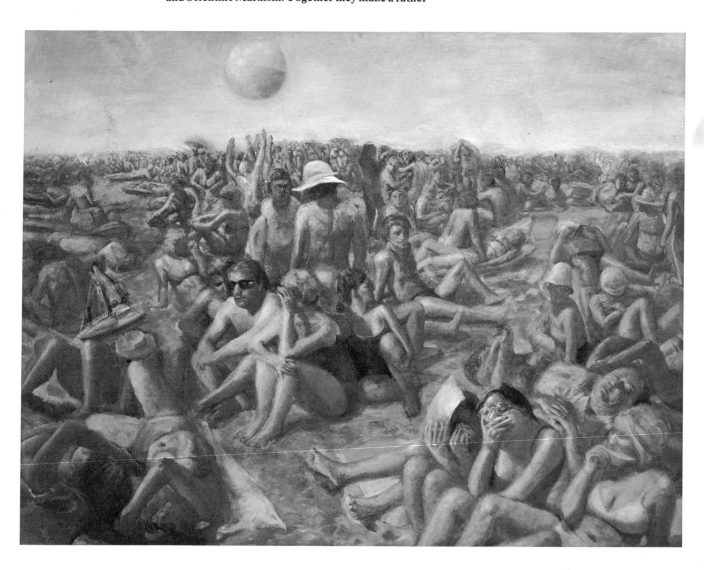

Gudrun Brüne:
And Again a Summer 1982
No.3

daunting list, but those students to whom I spoke implied that, although a serious attempt had to be made to answer the questions, it was the practical work that was most critical in assessment.

Not all students start their studies immediately after leaving secondary school; many of the artists shown here had some other employment before beginning their artistic training. Sighard Gille studied Agriculture, Volker Stelzmann worked as a motor mechanic, Walter Libuda as a painter and decorator while they studied at Evening Class to get the necessary qualifications to pursue full time art education. The eventual goal is the Diploma of Fine Art which is awarded in the fifth year on the completion of a satisfactory compulsory figure composition and a separate free composition chosen by the student. Such final works have by this time usually been commissioned in advance by public institutions. Post-diploma studies generally take the form of becoming a Master-pupil of a member of the Academy of Art. Here the teacher-pupil relationship is very close and both naturally tend to hold similar views.

On graduation young artists are able to apply for membership of the Artists' Union and their election depends upon their own artistic achievement, however once this hurdle has been overcome their future material security is ensured. The Union plays a leading role within the Art Establishment particularly as membership is a condition of finding work. Its influence extends into every sphere of the visual arts: in administration and welfare, at both national and local level, and as a kind of craft guild which maintains professional standards. It also has an important function in that it mediates the consensus between State, Party and individual artist. Willi Sitte, its President, plays a crucial role in articulating its political and social policy. Present membership stands at around 5000 but this includes sections for cartoonists, commerical artists, designers, craftsmen and art critics as well as for painters and sculptors. On a local level the fifteen branches work together to enable a co-ordinated planning of artists' placements through commissions, contracts and interest free loans. On being accepted for membership a minimum income is initially assured for the young artist through the provision of contracts for commissions to an agreed value.

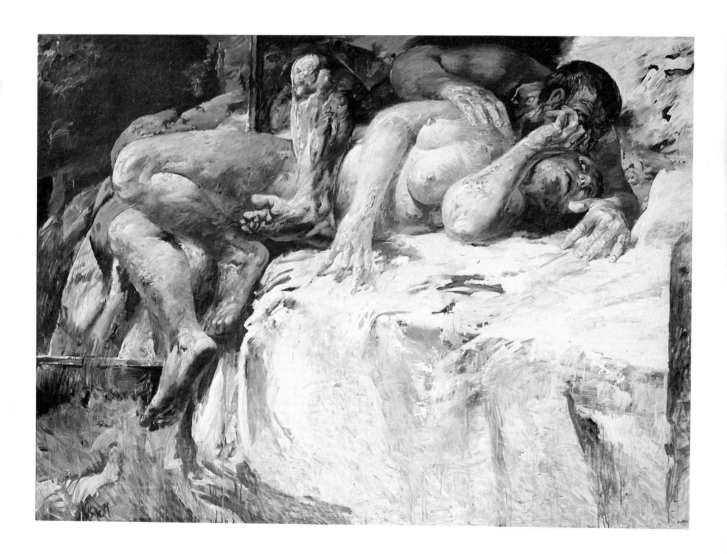

Willi Sitte:
Couple on White Sheet 1982
No.94

Purchases are also made by a small band of committed private collectors who live within the GDR whose function is to provide as much moral as financial support. But most sales take place through the twenty five galleries of the State Art Dealing Agency which are distributed throughout the country. In these special exhibitions are arranged and sales made to both local and foreign buyers. Trade here has recently been stimulated by an increased interest from foreign collectors, both public and commercial. Dr Peter Ludwig, patron of the new Museum in Cologne which bears his name and of collections shown in Aachen and Vienna, has, in particular, made many important purchases. Foreign dealers also, particularly from the German Federal Republic, have started to take an interest; last year the Galerie Brusberg in Hanover was instrumental in organising a large travelling exhibition of contemporary painting which was seen in major public spaces. A number of one-person exhibitions by established figures such as Heisig, Tübke and Sitte have also taken place as well as some smaller shows by younger artists. The productive irony of the growing popularity of socialist painting within the capitalist West is well recognised and there is clearly the start of a significant export market which can benefit both artist and state alike.

But the traffic has not been all one way. Younger artists such as Hubertus Giebe and Walter Libuda are now making work which, while retaining its own strong individuality and sense of position, can be seen partly as a response to that tide of new expressionism which is sweeping the West. There are also more formal links: a comprehensive exhibition of works on paper by Henry Moore is at present touring Art Museums in Berlin, Halle and Dresden and there is a strong interest in the future possibility of a major exhibition of twentieth-century British art. Let us hope that this is only a beginning. It may be that this exhibition of contemporary art from the GDR and other reciprocating exhibitions and events are the earliest steps in the establishment of a deeper mutual understanding. It is from such a basis that a fruitful relationship can develop.

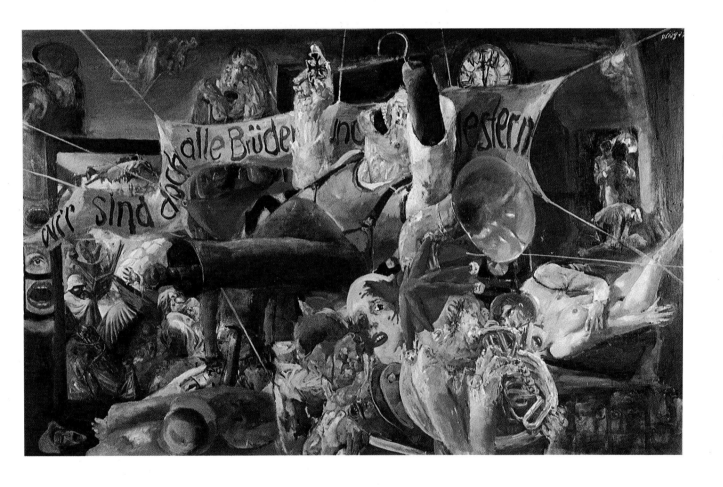

Bernard Heisig:
The Persistence of Forgetfulness 1977
Oil on canvas/145 × 240
National galerie, Berlin
Not in Exhibition

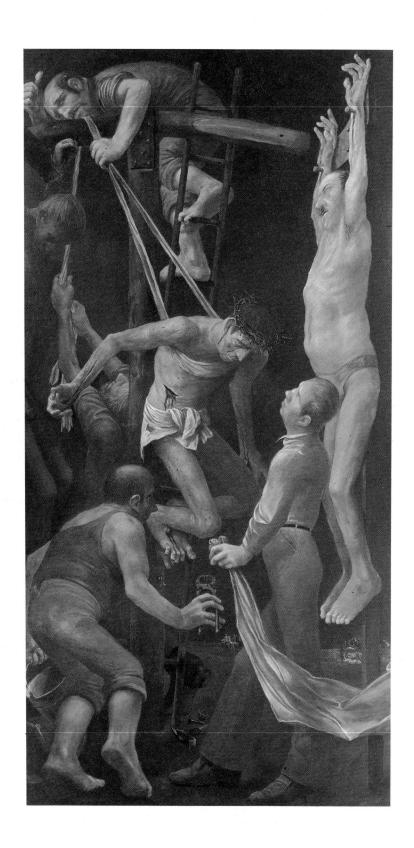

Volker Stelzmann:
Descent from the Cross 1978–79
Mixed media/233 × 120
Not in exhibition

Gabriele Wittrin:

CONTEMPORARY ART IN THE GERMAN DEMOCRATIC REPUBLIC

It is self-evident that nobody can live in a society, and at the same time be free from it. Hence everything we do or don't do has a political dimension, and that includes our work as artists.

Willi Sitte

This declaration by Willi Sitte, one of the most prominent painters in the GDR and the President of the Artists' Union, highlights the basic agreement of artists with the values and aims of our society. It is particularly relevant to the social and political conditions at the start of this new decade when the fundamental issue of conflict or peace is of vital importance; artists have reacted in their work to this either by a heightened expressiveness or by using a more analytical method. Indeed, how could art remain indifferent to those shocks and fears that unsettle so many people at a time of a awareness throughout the world of the threat to our very existence? This responsibility to human life, culture, and civilization was evident in many of the pictures in the last National Exhibition of Art held during 1982–83 in Dresden, and many engaged directly with these issues.

There are examples of both expressive and analytical works in this exhibition. The majority are indebted to the methods of realism, which has a continuity in our art, and which, especially at the beginning of the seventies, enriched conventional possibilities by the 'breadth and multiplicity' of its perspectives, and compositional techniques.

The so-called 'Leipzig School', which is strongly represented here, played a prominent role. In contrast to the fundamentally sensual style of painting that dominated the traditional centres of art in Dresden, Berlin and Halle, Leipzig artists, particularly those connected with the School of Graphic Art and Printing Design, have evolved a thoughtful and imaginative style which integrates historical subjects with present day circumstances in a way that has opened up many new possibilities for further development. The methods used by these artists are diverse: some are objective, others rational, still others highly expressive. These artists have an unselfconscious relationship with their own artistic heritage. In their work they have examined the past for statements of contemporary relevance. The art of progressive periods such as the Renaissance, that of times of social upheaval, like the late Gothic, Mannerism and the late Baroque, and especially the socially critical Verism of the twenties, have all attracted their attention. As a result, much of their art is characterised by multi-layered metaphors and allusions as well as by stylistic and iconographic references.

The technically accomplished oeuvre of Werner Tübke is, in this context, of especial interest both in its astonishing range and in its creative annexation of historical styles. His work is at its most compelling when analogies between different ages become apparent: the formal innovations of the High Renaissance allow for a topical multiplicity that characterises the values of rising social groups, while the artistic styles of historical turning points allude to outdated political and social realities. But this kind of painting would remain empty and academic without sensual contact with a direct experience of nature. Like many German artists of the past, Tübke found this stimulation in Italy where its artistic treasures, as well as the beauty of the landscape and people have time and time again inspired him; yet this work has also been invaded by a dissonance and uncertainty. Most recently he has again taken up his engagement with German history in a monumental panoramic painting for the memorial to the uprising of German Peasants in 1525 at Bad Frankenhausen.

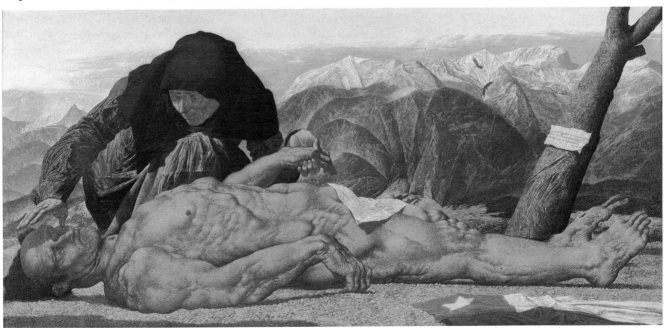

Werner Tübke:
Chilean Requiem
Mixed media on canvas on wood/54 × 115
Museum of fine Arts, Leipzig (Not in exhibition)

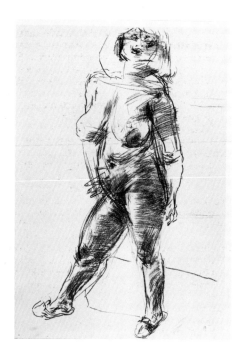

Sighard Gille
Standing Nude 1983
No.44

It is no coincidence that questions of historical guilt and suffering repeatedly exercise the generation of Werner Tübke, Bernhard Heisig, and Willi Sitte, who all had personal experience of the fascist inferno. Heisig speaks of his inner necessity for depicting historical themes and over many years has refined this in an increasingly dense series of paintings. With the exception of his earlier versions of the Paris Commune, his paintings do not depict specific historical episodes or events. Instead he invents memorable visual metaphors which he integrates like tableaux into new and different compositional contexts. Consequently chronologically incompatible features appear side by side, revealing complex backgrounds and connections. The coherence of his paintings is assured by a clearly arranged composition, a comprehensive gestural style and a seductive use of colour; the viewer is confronted by these qualities even when the utmost human depravity is shown. Heisig is a dramatist of both form and colour; his personal involvement is evident not only in the expressiveness of his style but also from his own presence which often appears in the work.

Willi Sitte has also played a significant role in evolving this new type of historical painting. By utilizing techniques of simultaneous depiction, typical of the twentieth century, he has managed to show that present revolutionary struggles are of current relevance to art. These programmatic, complex paintings are not available for this exhibition, yet the drawings for *Everyone has the Right to Live and be Free* and for *The Red Flag: Struggle, Grief, and Victory* can only hint at the baroque profusion that is typical of Sitte's oeuvre; the vehemence of his figures breaks through the barriers of pictorial space. Sitte has also added new dimensions to the portrayal of the worker. The workers in his brigade paintings radiate a joy of life quite free from any posturing. Sitte understands individuals with their distinct union of personal and social characteristics. Consequently even apparently private and intimate motifs articulate a new conception of self, a new moral order and naturalness. This is shown not so much in external attributes, but in the dynamic expression of strong bodies bursting with vitality, their forceful presence indebted to both Courbet and Corinth. The artist attains his most far-reaching individualisation in the portraits of his parents which demonstrate their separateness from previous treatments of the same subject by such artists as Otto Dix and Curt Querner in the 1920s and 1930s, by the depiction of the inner stability of the sitters' full and active lives.

Gerhard Kettner's graphic work is more self-contained and lacks such a programmatic dimension. It grows out of the humanist tradition of Dresden's graphic art, and widens its scope by adding socially accurate comment. Kettner observes the people around him, his relations, friends and fellow artists; he favours the strikingly featured faces of the old. His drawings show human beings in their inviolable dignity, their hopes and disappointments, yet their individuality is embedded within a collective life. With the limited means available to the draughtsman, Kettner asks fundamental questions about the meaning of human endeavour.

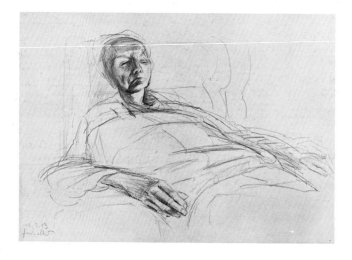

Gerhard Kettner:
My Father
(**Otto Kettner**) 1983
No.58

At the turn of the seventies the generation of artists, now in their forties, attracted a good deal of attention by their original and untrammeled perspective on life. Sighard Gille, Volker Stelzmann, Gudrun Brüne, and Hartwig Ebersbach took a critical and uninhibited look at everyday events and social relationships in our society. Their direct or even surrealist depiction of individuals and objects stimulated a dialogue with the public, who felt challenged to respond. This art did not offer any easy affirmation, but provided a demanding visual stimulus with multiple references, symbols and allegories. The formal language of a socially critical Verism was especially appropriate for the calculated harshness of these works.

This was the common point of departure for the Leipzig artists Sighard Gille and Volker Stelzmann, who represent very different compositional styles with the works shown here.

Volker Stelzmann's work has remained more indebted to an academic approach. With an unerring eye he sets out those circumstances or physiognomies which in the balance of time have moved him deeply. He distorts forms to provoke the viewer into countering deformity with an image of beauty, indifference to man's brutality with human sympathy. The triptych *Investigation* inspires concern about the nature of a meaningful life. But more recent paintings from the

eighties have changed: the pressing, falling figures lose in sharpness, even though they are intended to represent contemporaries. Strong modelling creates an unsettling contrast with areas which are out of focus and this results in a pervading sense of unease.

The veristic harshness of Sighard Gille's earlier works has made way for a more humorous and ironical view of his contemporaries. This is seen in his large group pictures of worker brigades and fellow artists. Here colour is used as an expressive means but Gille cannot be pinned down to any single compositional technique, he experiments. At first sight the artist's relation to his subjects – people, groups, and landscapes – appears undisturbed. Drawings serve to clarify visual ideas, as in his study for *Ferry* where his work gains a new dimension: the convincing realisation of human joy. The richly metaphorical visual language of this drawing is continued in his large mural, *Song of the Earth* in the Gewandhaus, the main Concert Hall in Leipzig. Both real and imaginary elements pervade his paintings which often take as their subjects his own personal and domestic happiness. Yet Gille's awareness of the tension of our times is made clear by his disruption of their stability.

Hubertus Giebe:
Double Portrait,
 Christopher and Linda II
 Oil on hardboard/140 × 160
 Not in exhibition

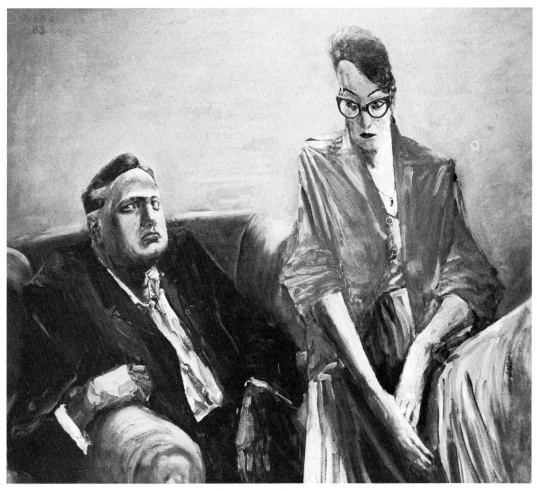

In her restrained sensual portraits and beach pictures Gudrun Brüne is concerned in an undramatic way with people and their relation to their natural surroundings. In earlier group paintings she singles out individual figures, but in this version of *And Again a Summer* she does not stress any individual or personal experience. Simple visual objects evince a quiet

thoughtfulness, and evoke thoughts of transience. In her *Self-Portrait with Heroes* Brüne places herself between pictures of Paula Modersohn-Becker, a pioneer of Expressionism in Germany, and Rosa Luxemburg, a founder member of the German Communist Party, clarifying her position as a woman in both art and society.

Hartwig Ebersbach:
Burning Man 1983
No.19

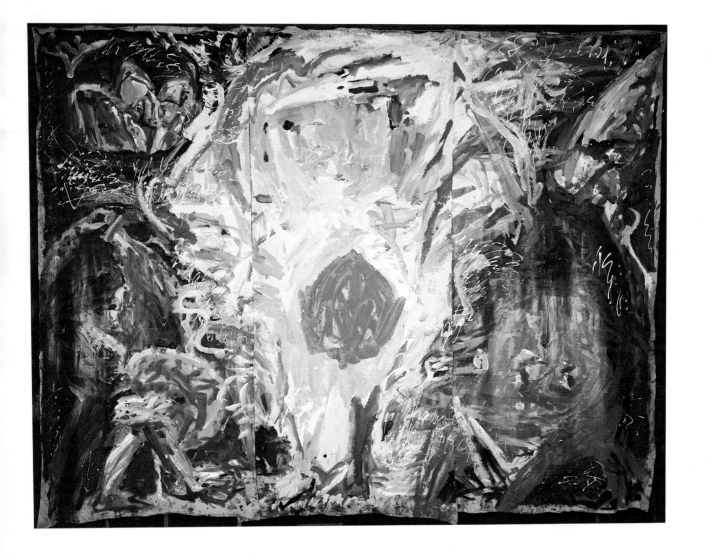

Hartwig Ebersbach does not engage the viewer by
any depiction of surface reality. His paintings with their
aggressive clashes and swirls of colour are like 'fields of
force' from which ecstatic tensions are released. His
expressive technique derives from Corinth, Kokoschka,
and from his former teacher Bernhard Heisig.
Ebersbach pursues his self-analysis – his artistic self-
definition – as a means of coping with life. At the core of
this is the merciless revelation of the opposition of
matter and spirit. The picture panels, flags and objects
in this exhibition would, however, be misunderstood if
one did not relate them to those pieces of work that show
themselves to be, for example, violent reactions to the
counter-revolutionary events in Chile. But even in these
distintegrated artistic structures, where open visual
forms and objects seem to spin off into the surrounding
space, the artist strives for a dialogue within society.

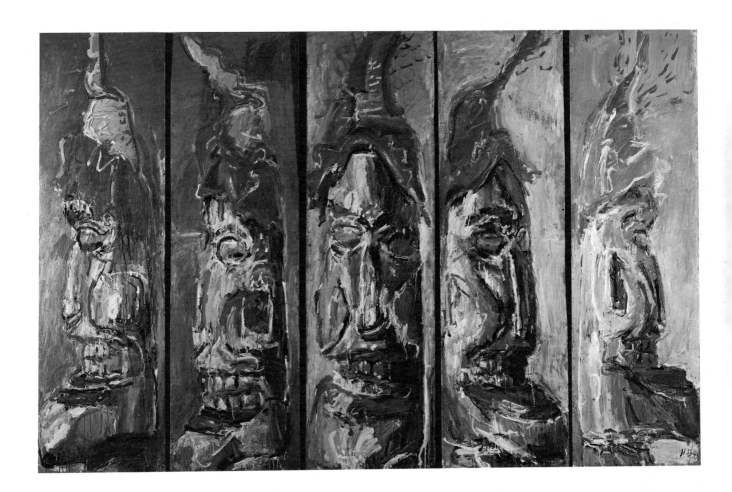

Hartwig Ebersbach:
Kaspar-the Development of a Portrait 1973
No.16

Like that of Ebersbach, the work of writer, draughtsman, and graphic designer, Carlfriedrich Claus, also cuts across traditional visual forms. His 'Language Sheets', as he himself calls them, inhabit a position somewhere between literature and visual art. Partly legible, partly abstract calligraphic signs are built into multi-referential graphic structures. The Language Sheets show the end point of a process of thought in which philosophical, historical and psychological questions have all played a part. If one follows his flowing, hesitating, and gnarled calligraphic gestures and is aware of their words and figures, one slowly understands what struggles have been involved in the cognitive processes which have framed their development. Although the visual structure of his work is complicated, Claus does nevertheless aim for a broadly based reception of his oeuvre.

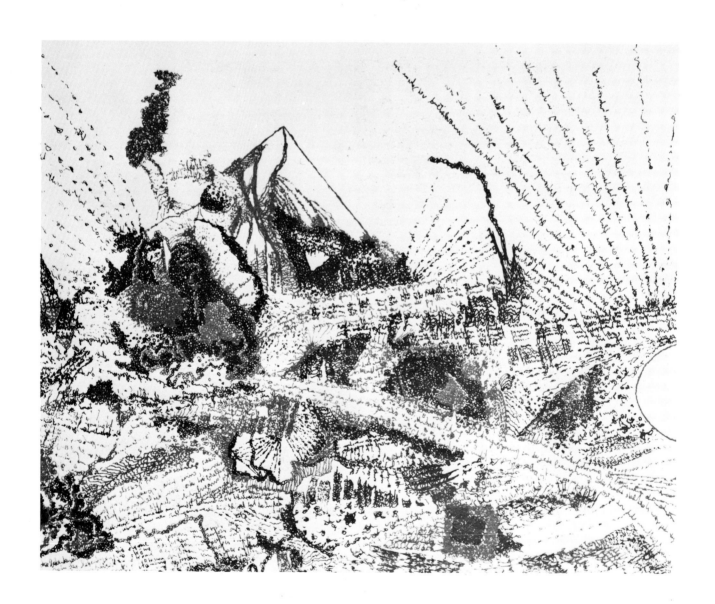

Carlfriedrich Claus:
Allegorical essay for Albert Wigand:
The naturalisation of Man,
the humanisation of Nature,
a communist problem of the future
1965–79
No.5

Amongst the graphic artists of the middle generation Jürgen Schieferdecker, and recently also Wolfgang Petrovsky, have gained attention for work that is, in the best sense, committed. Like the young Dresden painter Hubertus Giebe, they have found a common thematic base in the problems posed by the recent German political past. It is no coincidence that artists born in Dresden between 1940 and 1950 once again turn to this subject since the city still bears many signs of the destruction of its once splendid centre.

Jürgen Schieferdecker's montages and drawings are also reasoned attacks on contemporary injustice. He uses found materials which relate to other specific situations as well as foreign visual elements in his work. But together, these sometimes allow surprising insights – a principle already seen in Dada, Pop Art, and especially in the political photomontages of John Heartfield.

Schieferdecker's works are pre-eminently characterised by a density and originality of visual approach. It works to his advantage that painting was his starting point, and he now increasingly combines painterly and graphic features with the precise techniques of printing. This is sometimes shown in a sensual richness; the assemblage *The Thousand Year Reich* provides some insight into this method of work. The title and composition are derived from the visionary picture of the same name made between 1935 and 1938 by Hans Grundig, a Dresden artist, communist and anti-fascist. Schieferdecker's triptych presents a surreal cynical paraphrase of the religious form of painting. His subject is the brutality of a political system that has been condemned by history, and the outdated format and technique increases the viewer's unease. Schieferdecker appeals to the open-minded viewer who is prepared to decipher deeply encoded compositions. Nowadays nobody will be able to evade the directness of his question *A Fair Bomb (Isn't It?)*.

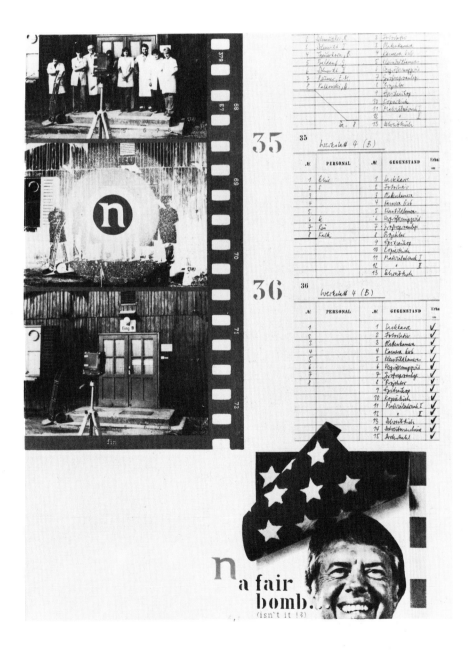

Jürgen Schieferdecker:
A Fair Bomb (Isn't It?) 1980
No.76

The generation of artists in their thirties is represented here by Hubertus Giebe, Walter Libuda, and Dagmar Stoev, who all share an inclination for emphatic expressiveness with an enjoyment of experimentation. Dagmar Stoev, the youngest of the three, is still in the process of establishing her own style, free from the influence of Bernhard Heisig, her teacher. The other two have already begun to exhibit their work more widely.

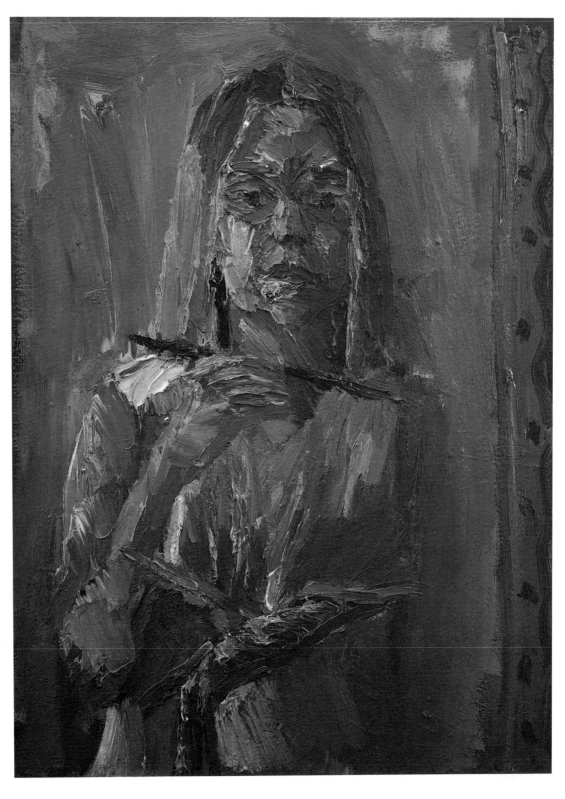

Dagmar Stoev:
Self-Portrait with Flower 1983
No.110

In the work of Hubertus Giebe its passion, strong intellect, and emphatic formal properties make an immediate impact on the viewer; these are as apparent in thematic large-scale works as in the range of work which includes his nudes. The nude female body is for him an expression of fundamental humanity, separate from the particular features of his model.

His taut and angular linearity and roughened areas of colour signal an existential threat. The direct character of his erotic compositions may well alienate some, and individual viewers may have problems with their reception. Nevertheless Giebe's nudes inspire hope, in their gentle modelling of bodies, their attenuation of aggressive shades of colour, and their newly-gained pictorial sensuality.

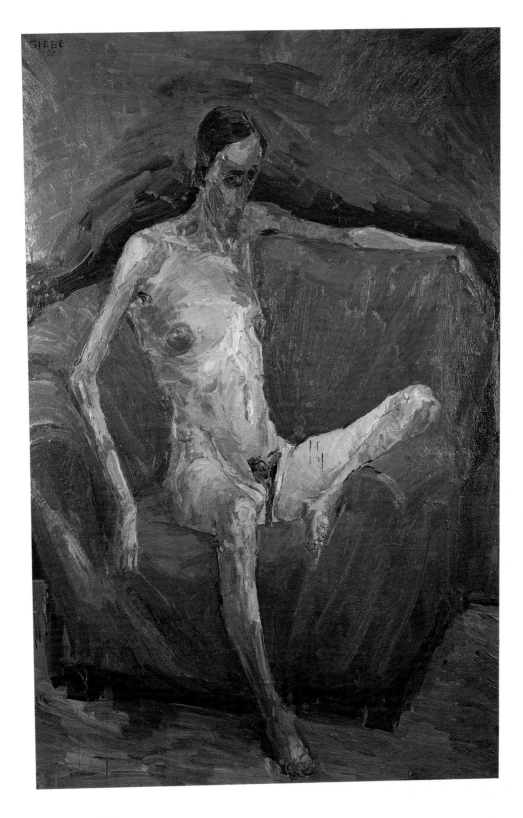

Hubertus Giebe:
Sitting Nude 1982
No.21

Walter Libuda sees it as his fundamental task to characterise in colour the substance of the figures and objects in his paintings. Often used as an unmixed impasto, it obliterates shapes under multiple layers of paint. His woodcuts also show his talent and technical competence. His wide ranging visual imagination discovers and invents figures and objects which, whether naked, or dressed in exotic costumes, are imbued with a sense of mystery. These figures act out their lives in flat, stage-like spaces, only made visible to us by the artist. Looking at his painting *Self* one is inclined to think that his powerful physique also appears in other works. They bear such titles as *Courtship* and suggest references to painful personal experiences, disappointments, and hopes. Such works are not easy for us to understand and defy any conclusive statements about their meaning. They present a striking climax to this selection of work

We hope that this exhibition will, through the quality of the work in it, contribute to the mutual understanding and peaceful co-existence of our nations, and that the cultural relations between our two countries will be strengthened as a result.

Translated by Wilf Deckner

Walter Libuda:
Self 1984
No.65

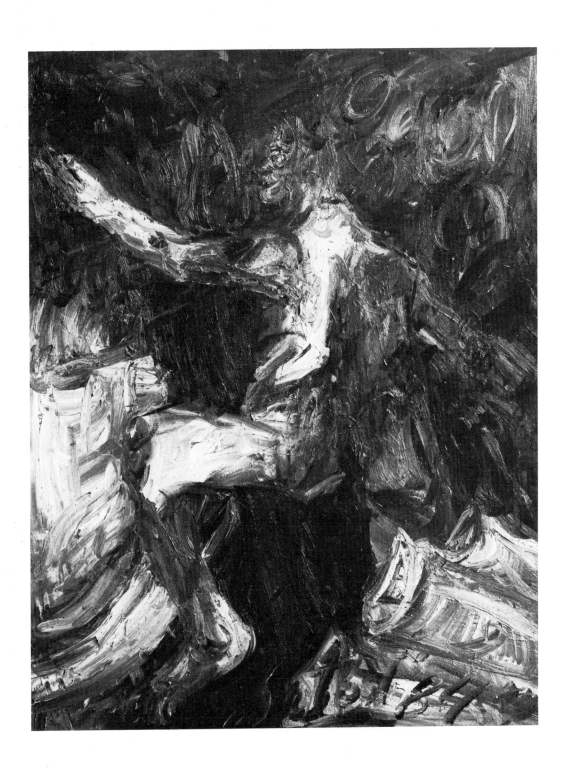

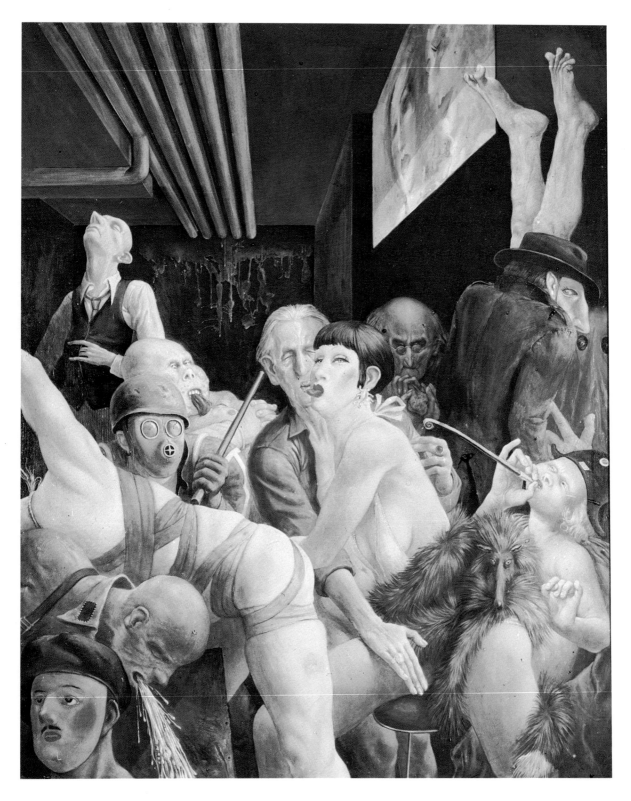

Volker Stelzmann:
Bunker Carnival 1976
Mixed media on hardboard/100 × 20
Nationalgalerie, Berlin
Not in exhibition

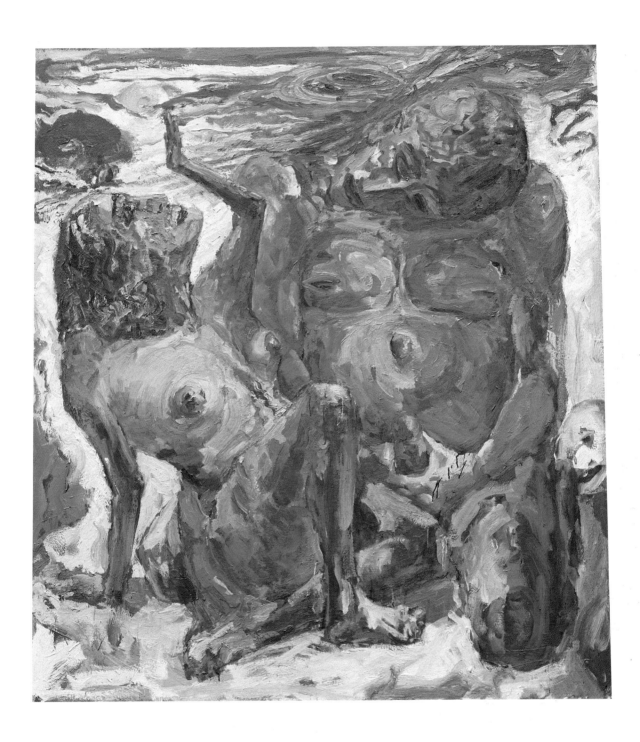

Hubertus Giebe:
On 'Isolated Gentleman' (Pablo Neruda) III 1982
No.20

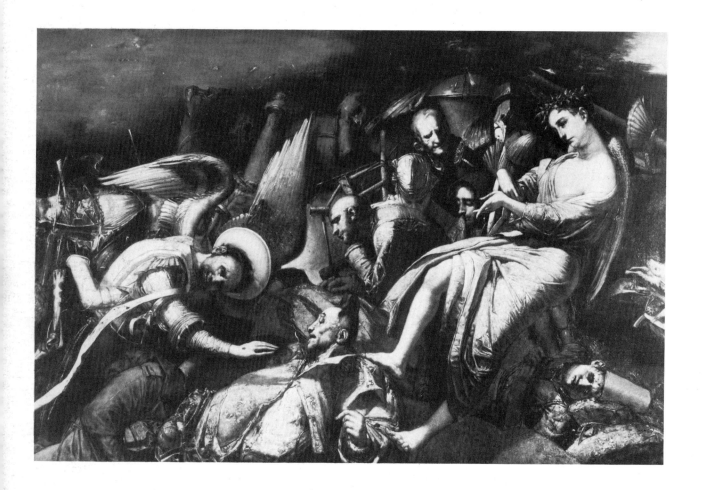

Werner Tübke:
The Last Judgement
from **The Early Bourgeois Revolution
in Germany** 1983
No.116

CATALOGUE

GUDRUN BRÜNE

I am trying to combat current fears and threats by striving to show an element of hope in my pictures: hope for the continuance of life, for a natural death, and for the preservation of traditional cultural values. My subjects are the human figure, nature in general. My themes cover the problems of co-existence and the growing isolation of the individual in a highly civilised, mass society. All these things concern me. I am working in the tradition of European art, and for me, there is no better means of expression for my intentions than realism.

Painter and graphic artist.
1941 Born in Berlin.
1956–59 Apprenticeship in bookbinding.
1961–66 Studied under Heinz Wagner and Bernhard Heisig at School of Graphic Art and Printing Design, Leipzig.
1966–77 Freelance.
1977– lecturer at School of Industrial Design, Halle. Lives in Leipzig.

3.
And Again a Summer
1982
Oil on hardboard
120 × 158
Illustrated in colour p.12

2.
Dying Sunflowers
1981
Oil on hardboard
100 × 300

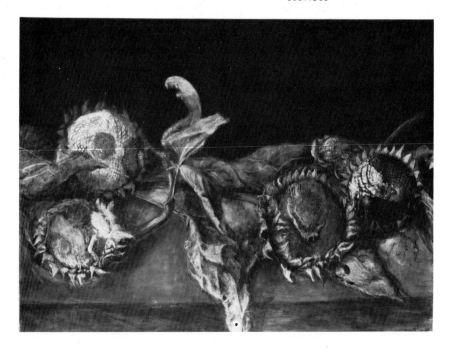

1.
Self-Portrait with Heroes
1980
Oil on hardboard
100 × 130
Cultural fund of the GDR

CARLFRIEDRICH CLAUS

Language sheets create an area on the boundaries of literature. The awareness and the use of these respective dialectics make it possible to bring hitherto separate areas into contact, and to create new areas. . . Their structure is internally contradictory. The achieved optical unity belongs by virtue of its elements to another sphere of information, that of linguistics. These experimental sheets are therefore intended to be perceived as optical systems, as well as to be *read* as linguistic information, unfolded in chronological sequence. As a result of the intended dissolution of these two levels of information, the optical and the linguistic, into each other comparison and the forging of new connections is made easy; a new specific tension can be seen by both readers and viewers. They perceive the conflicts, contradictions, tensions, and struggles between the two levels and take up their own position, in order to intervene actively in the discourse taking place on the sheet.
(in *Zwischenbemerkungen*, 1976).

	Writer, graphic artist and designer.
1930	Born in Annaberg.
1951–	Experimental poetic texts and sound collages.
1953–54	Journalist for *Volksstimme*, Karl-Marx-Stadt. Worked mainly on theatre reviews.
1958–	First language sheets.
1958–60	Phase models and letter fields on typewriter.
1959	Experimental language processes on tape.
1968–	Reproductions of language sheets by various means including transfer-type lithographs and etchings on zinc and aluminium.
1975–	Member of Artists' Union of GDR. Lives in Annaberg-Buchholz.

4.
Allegorical essay from Albert Wigand:
The naturalisation of Man, the humanisation of Nature, a Communist problem of the future
1965/1979
Silk-screen print on both sides of tracing paper.
70 × 85.5
Illustrated p.22

5.
Conjunctions, unity, and struggle of contrasts in landscape, in relation to the Communist problem of the future, the naturalisation of Man, the humanisation of Nature 1967/1982
Silk-screen print on both sides of tracing paper.
43 × 60

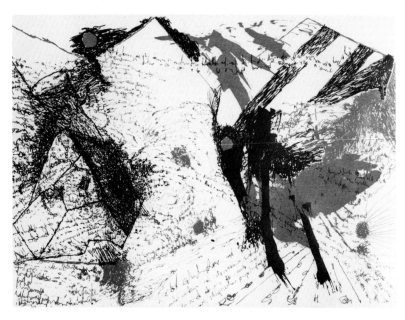

6–15.
Aurora
1975/1977
Portfolio of 10 etchings. 1977
On each etching's envelope of tracing paper there is a quotation, written by Claus and printed in offset, from the following authors: Sheet 1: P.Eluard; 2: Dschuang dsi; 3: J.W. Goethe; 4: V.Lenin and C.Zetkin; 5: Dante and K.Marx; 6: J.Böhme and V.Lenin; 7: K.Marx and V.Lenin; 8: Jehuda Halévi and Paracelsus; 9: Fr. Engels; 10: E.Bloch.
Centre for Art Exhibitions of the GDR

7.
2: The gallows will turn green
13 × 13.6

9.
4: The processes of realising new relations between men and women ·
I: Activating the negation of the sexual instinct; a change of instinct; synthesis. The genesis of a new consciousness / 20 × 14.7

10.
5: The processes of realising new relations between men and women
II: Communication independent of distance by means of signs imaginatively generated and animated in the heart / 19.6 × 13.5

11.
6: The processes of realising new relations between men and women
III: Active psychic exchange of energies; effect on degree of activity / 20 × 15

14.
9: Between microcosmic and macrocosmic
19.8 × 14.5

15.
10: Question about a Communist cosmology
19.8 × 14.5

6.
1: **The Aurora signal of the Russian October.**
Advance signal and real beginning of universal
changes / 17.1 × 13.5

8.
3: **Childhood imaginings: Aurora in them**
18 × 14.7

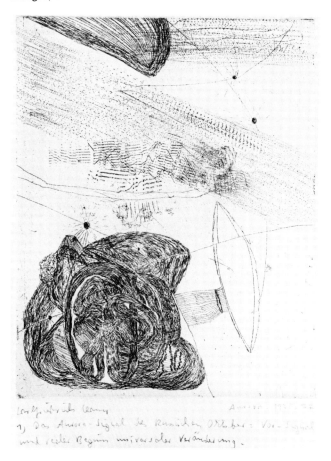

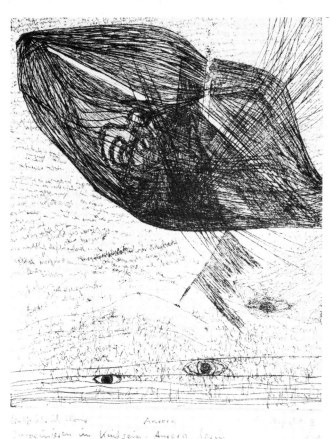

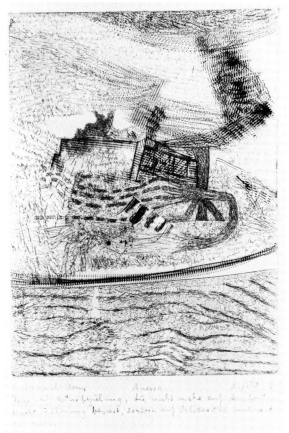

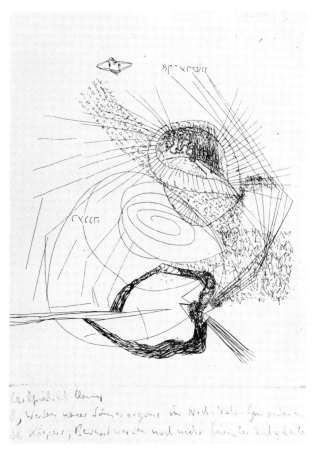

12.
7: **Question about a relation to nature not based**
on exploitation, power of subjugation, but on a
solidarity with Nature / 18.7 × 14

13.
8: **The rise of new sense organs in the nascent**
areas of the body; growing awareness of not yet
conscious abilities / 18 × 14.5

HARTWIG EBERSBACH

Burning Man: this work is related to a dream in which I was burning, my belly was glowing, around me several figures, some disguised, some retreating, and a very disturbing red animal.

The work is no simple reproduction of this scene. The event, the composition, the scenario, are only the foreground (the occasion) for a repetition of the emotional experience (the psychological drama). The picture as a whole is also the primary level of experience.

My particular interest lies in the possibility of establishing access to the latent areas of our psyche, of finding the point where emotions become physical experiences and where expression becomes meaning, whereby painting becomes a means to an end. That is the second level of experience. Anyone who wants to learn something about me would have to approach my pictures closely. Only then could information or further questions about me be perceived via the structures and gestures within them.

The picture flags were painted on the floor. I was right in the middle of the paint itself, and this also explains the footprints.

The most important realization for me [in *Burning Man*] was that the glowing belly and the red animal were identical, in psychological terms the Id potential in opposition to the Ego potential. The force field of the self, the fundamental human contradiction, has developed into the subject of my art. *Burning Man* is a key picture in this context, all other work is related to it.

I address the fundamental contradictions of human biology in this representative way as well as the two-way contradictions between the relationship of the individual (artist) and society. My work relates to the awareness of such tensions in order to allow a greater understanding or even abolition of them. This is how I transform them into creativity.

16.
Kaspar – the development of a Portrait 1973
5 panels; oil on hardboard
Each panel 199.5 × 60
Museum of Fine Arts, Leipzig
Illustrated in colour p.21

19.
Burning Man 1983
3 flags, oil on cloth
Each flag 290 × 130
Illustrated in colour p.20

	Painter and graphic artist.
1940	Born in Zwickau.
1957–59	Instructed in figure drawing and free composition by Carl Michel, studied painting with Tatjana Lietz at the School of Painting and Drawing at Zwickau.
1958	Practical year as worker on building site.
1959–64	Studied under Bernhard Heisig at School of Graphic Art and Printing Design in Leipzig.
1965–78	Freelance painter and exhibition designer.

1978	Co-operation with Leipzig composer Friedrich Schenker on *Kammerspiel II—missa nigra*.
1979–	Lectureship at School of Graphic Art and Printing Design in Leipzig, specialization: experimental art.
1981	*Missa nigra* premiered at Montepulciano/Sienna and Rennes. Lives in Leipzig.

Somersault in Paris 1983
Latex and acrylic on cloth
Not in exhibition

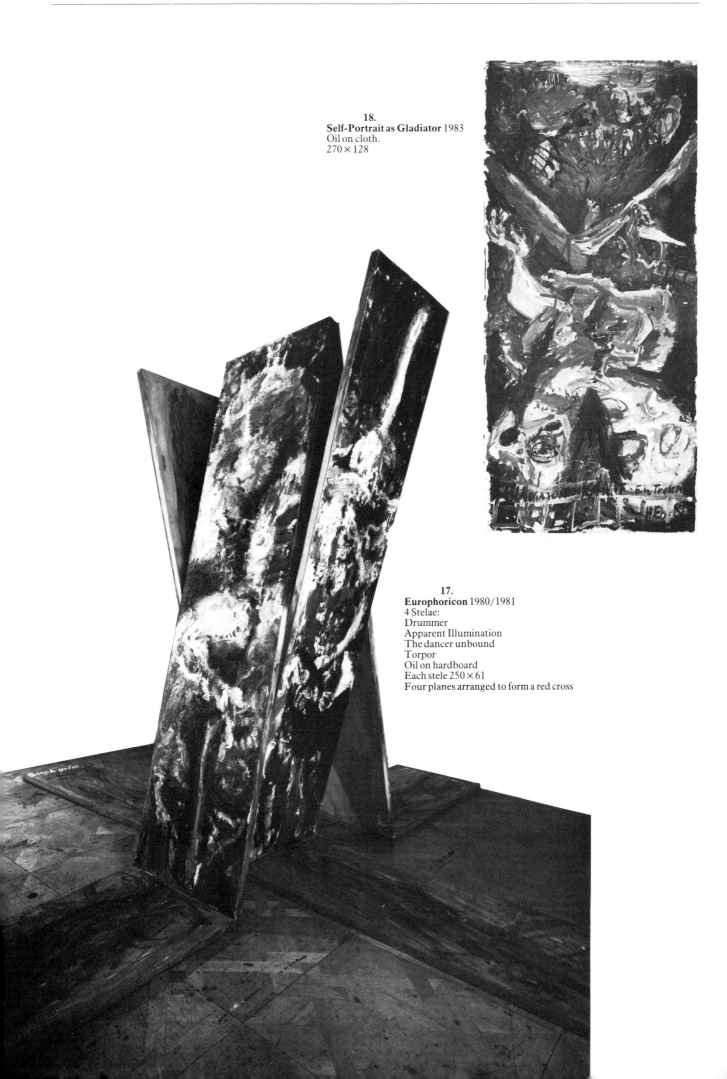

18.
Self-Portrait as Gladiator 1983
Oil on cloth.
270 × 128

17.
Europhoricon 1980/1981
4 Stelae:
Drummer
Apparent Illumination
The dancer unbound
Torpor
Oil on hardboard
Each stele 250 × 61
Four planes arranged to form a red cross

HUBERTUS GIEBE

One of the selected pictures is related to a poem by Pablo Neruda which is taken from the first volume of *Sojourn on Earth;* powerful and rich in images, Neruda described it as 'full of the world's sadness'...

These works contain a factual report of the world as well as a romantic longing, touching on the un-nameable and cosmic. They were created out of a passionate desire for life which longed for oases of beauty, for islands of justice in a world which was experienced in bitter-sweet ecstasy.

Motivation can arrive from anywhere, and my reason for working creatively does not only lie in the small world of my own personal circumstances, or in my national cultural tradition. It is rooted in the wide development of world culture and history.

Equally it arises from the simplest and most difficult things one can paint: heads, nudes, spaces. They are analogies for our strange and burgeoning existence; they are tangential and preserve on the inside, behind our eyes, centuries of tradition, portrayals of life—fixed in works of art.

My pictures are wholly concerned with people and the network of their relationships. Hence also my interest in literature, in poetry, in the agile world-theatres of film and writing. Consequently neither the human image nor subjects, old or new, are lost, forbidden, or meaningless to me. Beckmann, Egon Schiele, Picasso, and Rouault are great examples and a challenge to our century; they are a phalanx against the consuming 'isms' of modern art which represent an ever greater loss of expressive ability.

Painter, graphic artist and designer.
1953 Born in Dohna.
1969–72 Attended evening school of the School of Fine
 Arts in Dresden.
1973 Worked as dispatcher.
1974–76 Studied at School of Fine Arts, Dresden.
1978–79 Master pupil of Bernhard Heisig.
1979– Assistant Lecturer at School of Fine Arts,
 Dresden.
 Lives in Dresden.

20.
On 'Isolated Gentleman' (Pablo Neruda) III
1982
Oil on hardboard / 160 × 145
Illustrated in colour p.29

21.
Sitting Nude 1982
Oil on canvas / 180 × 120
Illustrated in colour p.25

23.
Standing Nude 1983
Oil on canvas / 95.5 × 74

24.
Semblance and Shock (to Walter Benjamin)
Oil on canvas / 70 × 90

25.
Two Dolls I 1980
Pencil on graph paper / 59.5 × 42

27.
Lying Nude I 1980
Pencil / 42 × 59.5

29.
Nude Bending Over (to the Left) 1981
Pencil / 59.5 × 42

30.
Nude Bending Over (to the Right) 1981
Pencil / 59.5 × 42

32.
Girl Standing and Bending Down 1981
Pencil / 59.5 × 42
Museum of Fine Arts, Leipzig

26.
Two Dolls II 1980
Pencil on graph paper / 59.5 × 42

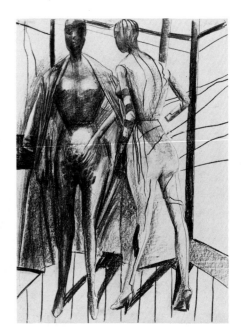

28.
Lying Nude II 1981
Pencil / 58 × 78.5

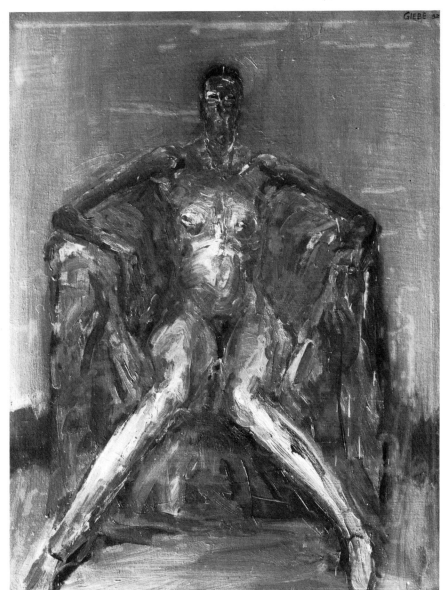

22.
Small Sitting Nude 1982/1983
Oil on canvas / 95.5 × 74

31.
Sitting Nude 1981
Pencil / 59.5 × 42

SIGHARD GILLE

Groups of people in certain situations, that's what inspires me again and again. Feasts, festivals, and fêtes offer first-rate possibilities. The surroundings, the relaxed or inhibited attitudes of the participants, any unusual features make it possible for me to recognize characters and patterns of behaviour, not to mention the stimulating sensuality of light, colour and structures.

I construct my pictures, set up the relationships and positions. In the first instance everything follows from my own experience, added to which there are my ideas or my knowledge about substance and representation and the relationship between them. Occasionally I react to the stimulus and the chance features of the subject itself. The many inner tensions, tendencies, or indifferences within a society have to be transposed into a visual image.

I strive to retain people's individuality even in group portraits. I like to use exaggeration bordering on caricature. Irony and self-parody should be included. To be able to laugh about oneself. . . I do not want to place myself above others; I am one of 'them', too. I show extremes because they exist, I definitely don't want to moralise.

34.
Study for 'Ferry' 1977
Mixed technique on wood / 81 × 54
Illustrated in colour inside front cover

35.
Self-Portrait in March 1978
Oil on hardboard / 57 × 57

36.
Fête in Leipzig 1979
Mixed technique on canvas / 113 × 171
Illustrated in colour p.10

Painter and graphic artist.
1941 Born in Eilenburg.
1959–60 Studied agriculture at Humboldt University, Berlin.
1961–64 While working in Leipzig attended evening school of School of Graphic Design and Printing, also worked as a photo-journalist.
1965–70 Studied with Berhard Heisig and Wolfgang Mattheuer at School of Graphic Art and Printing Design, Leipzig.
1971–73 Free-lance painter and branch steward.
1974–76 Master pupil of Bernhard Heisig at the Academy of Art of the GDR at Berlin.
1977 Probationary lectureship.
1978–80 Assistant Lecturer at School of Graphic Art and Printing Design in Leipzig.
1980–81 Work on mural *Song of the Earth* at the Gewandhaus, Leipzig.
Lives in Leipzig.

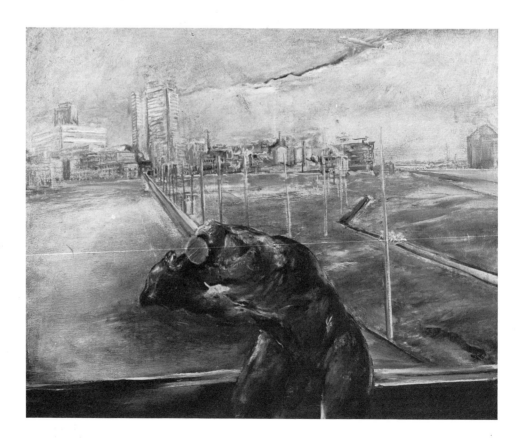

33.
Berlin Studio Window 1976
Oil on hardboard / 71 × 89

39.
Portrait of a girl 1979
Black crayon 59.2 × 42

40.
Nude and Easel 1980
Pencil / 76.3 × 56.5

41.
New Year 1982
Black crayon / 44.2 × 44.2

38.
Study for 'Ferry' 1976–77
Pen, brush, ink, black crayon / 59.2 × 42

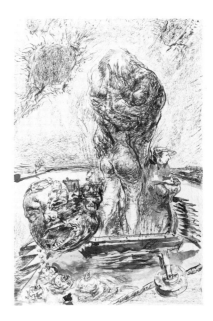

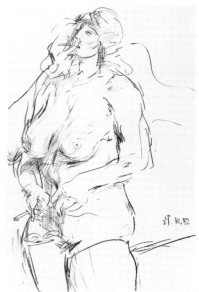

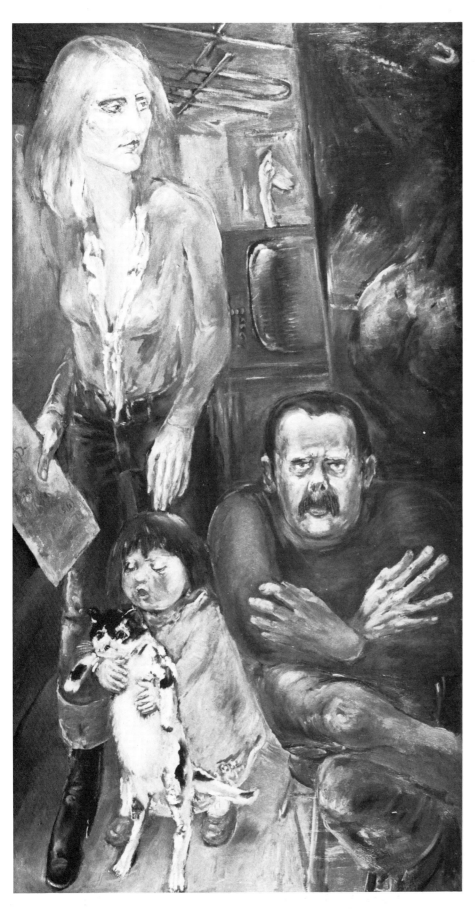

37.
The Peuker Family 1979
Mixed technique on hardboard / 170 × 91

42.
Nude with Cigarette 1982
Charcoal / 73.5 × 51.2

43.
Half-Reclining Nude 1982
Charcoal / 73.5 × 51.1

44.
Standing Nude 1983
Black crayon / 72.9 × 51.1

45.
Reading Nude 1983
Charcoal / 72.9 × 51.1

BERNHARD HEISIG

. . . no nation can live without its past, without it there is no nation, and of course no visual art either, no architecture and no towns. A nation without a history is incapable of making art. Nobody should try to tell me that Picasso, Klee, or Beckmann, did not know that either. The Old Masters knew it anyway. I am not going to claim that this is the only stimulus for creative work, but perhaps this does again allow us access to something approximating the great themes, it makes it possible for us to shift away from an egocentric position, to see things from a fresh vantage point, and to consolidate our techniques. From speech at VIII. Congress of Artists' Union of the GDR, 1978

46.
Fortress Breslau: The City and Its Murderers
1969
Oil on canvas / 180 × 171
Staatliches Lindeau-Museum, Altenburg
Illustrated in colour p.11

Painter and graphic artist.
1925 Born at Wroclav (Breslau).
1941–42 Studied with Eberhard Holscher and Wilhelm Rall at the School of Applied Arts, Breslau.
1942–45 Military service.
1946–47 Graphic designer in the Office for Information and Propaganda, Wroclav.
1948–49 Studied at School of Applied Arts, Leipzig.
1949–51 Studied with Max Schwimmer and Walter Münze at School of Graphic Art and Printing Design, Leipzig.
1951–54 Freelance.
1954–68 Teacher at School of Graphic Art and Printing Design, Leipzig.
1956 Appointed Reader.
1961 Appointed Professor.
1961–64 Appointed Director.
1965–68 Head of Department of Painting and Graphic Art.
1968–76 Freelance.
1972 Appointed member of the Academy of Art of the GDR.
1974– Vice-President of Artists' Union of GDR.
1976– Returned to post as director at School of Graphic Art and Printing Design, Leipzig. Lives in Leipzig.

The Sorcerer's Apprentice II 1975–81
Oil on canvas/150 × 200
Galerie Brusberg, Hanover
Not in exhibition

47.
Change of Heroes 1973/1974
Oil on canvas / 140 × 90
Museum of the Army of the GDR,
Dresden

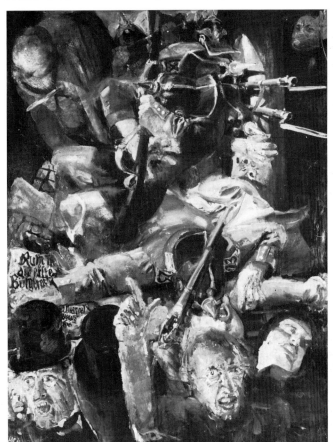

48.
The Prime Civil Duty 1977
Oil on canvas / 200 × 150
Museum of the Army of the GDR,
Dresden

GERHARD KETTNER

50.
Otto Kettner 1976
Graphite / 60.5 × 41.9

53.
The Sick Mother (Lucie Kettner) 1977
Graphite / 29.5 × 41

54.
The Sick Mother (Lucie Kettner) 1977
Graphite / 17 × 21.5

55.
The Sick Mother (Lucie Kettner) 1977
Graphite / 17 × 20.5

57.
The Miner, Lothar Querengässer II 1982
Graphite / 41.8 × 60.2

58.
My Father (Otto Kettner) 1983
Graphite / 41.5 × 59.7
Illustrated p.18

59.
Otto Kettner 1983
Graphite / 41.2 × 59.7

60.
Johannes Heisig 1983
Graphite on tinted paper / 52.5 × 43.5

Graphic artist and designer.
1928 Born in Mumsdorf/Thuringia.
1943–44 Apprenticeship as lithographer.
1944–47 Miliary service and POW.
1948–49 Studied with Heinrich Burkhardt at Lindenau-Museum School, Altenburg.
1949–51 Studied at School of Fine Arts, Weimar.
1951–53 Studied with Hans Grundig and Max Schwimmer at School of Fine Arts, Dresden.
1953–55 Assistant to Hans Theo Richter.
1956 Probationer with Max Schwimmer.
1956– Teaching at School of Fine Arts, Dresden.
1969 Appointed Professor.
1970–74 Director of School of Fine Arts, Dresden.
1973–77 Vice-President of Artists' Union of GDR.
1978 Appointed Member of Academy of Art of GDR.
1979–81 Returned to post of Director of School of Fine Arts, Dresden.
Lives in Dresden.

56.
The Sick Mother (Lucie Kettner) 1977
Graphite / 16 × 21

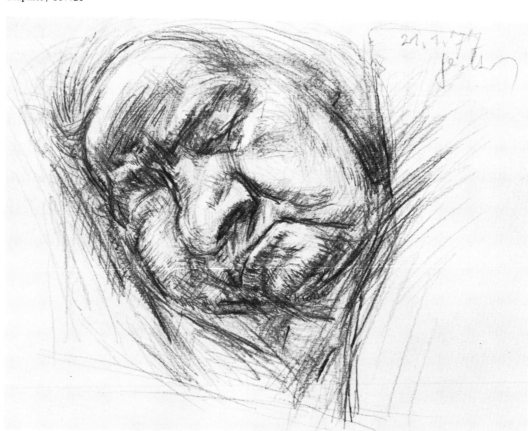

49.
Walter Fröhlich 1976
Rubbed graphite / 59.1 × 41.5

51.
Lucie Kettner 1976
Graphite / 58.5 × 41.1

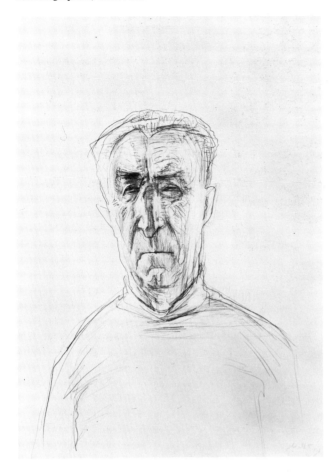

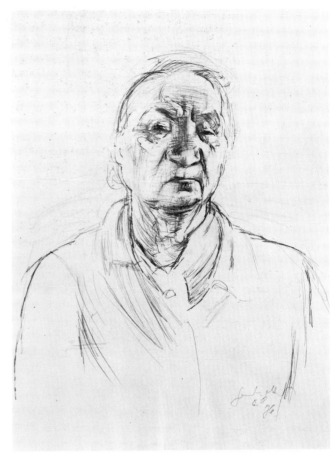

52.
The Sick Mother (Lucie Kettner) 1977
Graphite on tinted paper / 29.4 × 42

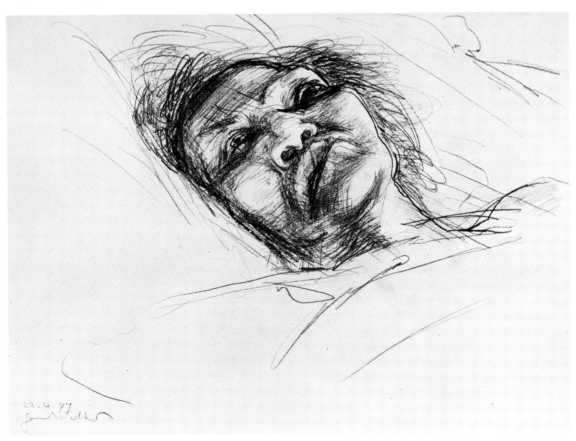

WALTER LIBUDA

The daily walk into the same room.
There is the table, the window, the door
to the next room that does not close properly.

The familiarity of the objects, the mundane details of a room, of a given situation, are
transformed by me.
The relationship between me, my moods, and my subject begins.
The familiar becomes strange and peculiar, the situation changes and becomes a
departure for a new constellation of activity.

Visual ideas do not originate only from concrete occasions.
They are the result of my stored experience, transmuted in the picture.

Painting as adventure.
The layering and melting of colour accompanies their making.
The original motivation is more and more suppressed.
The nature of the things I paint is relativised in the elaboration of their image.

62.
The Courtship IV (Marie) 1983
Oil on canvas / 110 × 100
Illustrated in colour p.vi

63.
The Discovery 1983
Oil on canvas / 131 × 140

64.
Bengal machine 1983
Oil on canvas / 101 × 101

65.
Self 1984
Oil on canvas / 141 × 110
Illustrated in colour p.27

Painter and graphic artist.
1950 Born in Zechau-Leesen.
1965–69 Apprenticeship and work as decorator.
1969–71 Set designer at Regional Theatre Altenburg.
1973–78 Studied with Hans Meyer-Foreyt, Ulrich Hachulla, Arno Rink, Bernhard Heisig, at School of Graphic Art and Printing Design, Leipzig.

1979–80 Assistant Lecturer at the Leipzig School.
1980–82 Freelance; helped Gille on the Gewandhaus mural.
1982– Returned to post as Assistant Lecturer. Lives in Leipzig.

The hallway in Libuda's Leipzig tenement

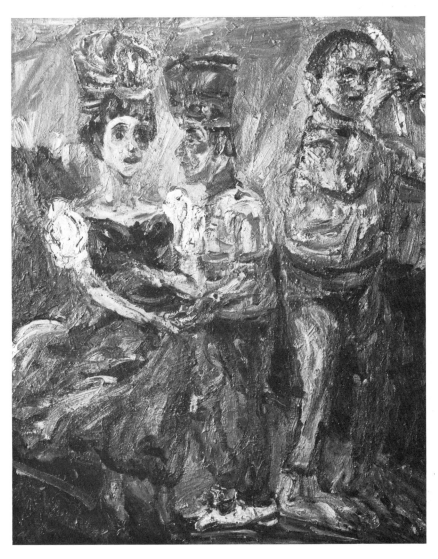

61.
The Courtship II 1982/1983
Oil on canvas / 101 × 81

67.
Pietà 1981
Woodcut / 40 × 45

68.
The Swing 1981
Woodcut / 39 × 46

69.
The Find or The Forgotten Title 1981
Woodcut / 46.2 × 39.4
Centre for Art Exhibitions of the GDR

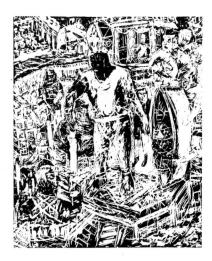

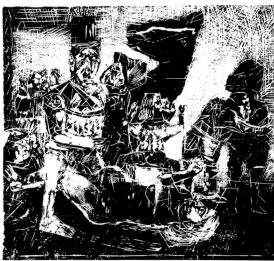

66.
Birth 1980
Woodcut / 40 × 45

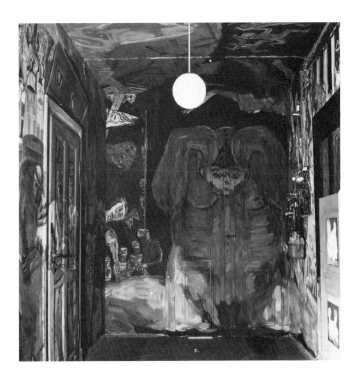

WOLFGANG PETROVSKY

Montage is suitable for the rapid illumination of social relationships even in a subliminal way. Screen prints are a powerful contemporary technique almost like a relief (as opposed to the 'flat' offset); detached and objective, they prevent a surfeit of sentimentality. They can be printed in large numbers and reach a large audience.

Collage, prints, postcards – a way to keep a diary, a happy combination of an obsession with work and a self-punishing search for an identity.

Research in the past gives insight into the present.
Search among bygone days prepares for the future.

FRANK VOIGT

1946 Born in Dresden.
1963–68 Apprenticeship and work as mechanic.
1969–74 Studied at School of Graphic Art and Printing Design, Leipzig.
1974– Freelance.
1982– Collaboration with W. Petrovsky in production of large scale visual panels and prints.
Lives in Dresden.

WOLFGANG PETROVSKY
Painter and graphic artist.
1947 Born in Hainsberg.
1962–66 Apprenticeship as carpenter.
1966–70 Studied at Institute of Art Teaching, Karl Marx University, Leipzig.
1973–79 Officer for fine art for Dresden county council.
1979– Freelance.
Lives in Freital, near Dresden.

70–73.
From the sequence **On German History** 1983
Silk screen prints. Wolfgang Petrovsky only

71.
Memory of 13th February 1945, the Destruction of Dresden
89 × 68.2

72.
In Honour of Rosa Luxemburg VI
98.5 × 66

74–78.
From the portfolio *Shrove Tuesday and Ash Wednesday, dedicated to the City of Dresden which was destroyed on 13th February 1945*
Silk screen prints. Petrovsky and Voigt together

74.
Signs of Life
58 × 80

76.
Cross Above Dresden
54 × 75
Illustrated in colour p.8

78.
Where there is a Valuable Inheritance, a Multitude of Children is a National Duty
50 × 60

70.
New Personality
83 × 56

73.
1920/1983
77 × 51

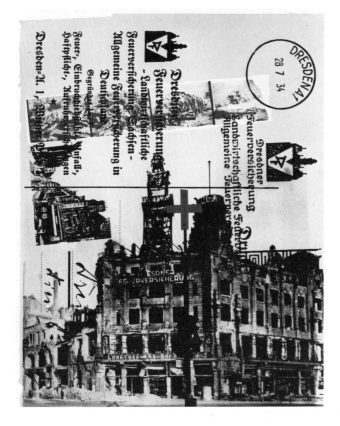

75.
Fire Insurance
79 × 62

77.
In Memoriam
79 × 62

JÜRGEN SCHIEFERDECKER

When I started to concern myself with the question of the use of materials in pictures, this was not without some knowledge of similar experiments in the West, but from the outset I set myself in deliberate opposition to the largely playful manner in which this was done there. The reason for this presumably lies in the difference of the respective starting points – their respective ideologies.

As so many of my contemporaries I was trying to find answers to questions that recent history had posed, especially for those who, because of their youth, could not be held responsible for its events. The traditional styles of painting did not always seem adequate to me for the treatment of these, or for the complexity of current problems.

Different related idioms, such as Brecht's epic theatre and the multimedia techniques of the Middle Ages or of the Baroque encouraged me – apart from the stimulation inherent in the materials themselves – to add elements to painting. Its nature was not decided from the very start, but it had to be able to engage the viewers and enable them to reach their own conclusions.

Seen in this light, Material Art – like collage, of which it is the spatial extension, – is no mere technique, but a method. Its use counteracts the shock of authenticity of documentary photography, and acts as a paradigm of the complexity of the problem that is represented in the world around it. The formal properties of the work show the viewer that this is not a statutory pronouncement, but a dialectic suggestion, and that possibly his own views can be negotiated within it.

Architect, painter, and graphic artist.
1927 Born in Meerane.
1955–61 Studied at Technical College, Dresden,
 received teaching in painting and drawing
 from Georg Nerlich.
1962–76 Lecturer at Technical University, Dresden.
1974 Appointed member of Artists' Union of GDR.
1976– Chairperson of artistic council of Technical
 University, additional lecturing.
 Lives in Dresden.

82.
The Cry of Icarus 1971
Oil on hardboard
39 × 28.5
Private collection

84.
Cartography I 'Feuerland' (Tierra del Fuego)
(continental art no.3) 1977
Letterpress print on polyester foil
49.5 × 43.5
Illustrated in colour p.9

88.
A Fair Bomb (Isn't It?) 1980
Photo-lithograph
63.5 × 44.5
Illustrated p.23

89.
Hubris 1981
Colour lithograph
46.5 × 62

90.
In the Course of Time 1981
Collage
48.37

79.
The Lost Key or **My Little Triumphal Avenue**
1965
Oil on hardboard
40 × 60

80.
The Thousand Year Reich or **The Chickens and the Egg** 1966
Triptych with predella. Assemblage
38.5 × 41/38.5 × 21.5/15.5 × 41

81.
Mlle Goebbles or **The Pretty Lie** 1966
Inset in front of mass-produced wireless set
(popular in Third Reich) 1966
Assemblage / 36 × 35

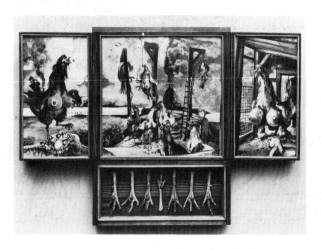

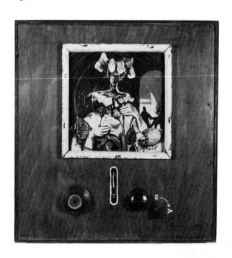

83.
In the Sight of the Gun: Babel 1976
Lithograph in 2 colours
58.3 × 44.5

85.
'My Cape of Good Hope' (continental art no.2)
1977/1978
Letterpress print on polyester foil / 49.5 × 43.5

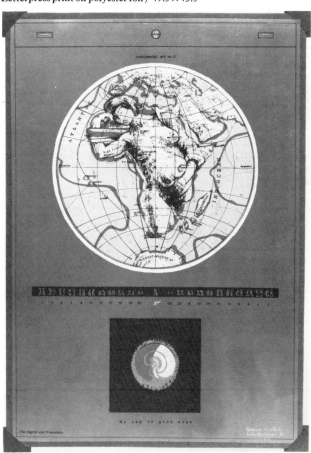

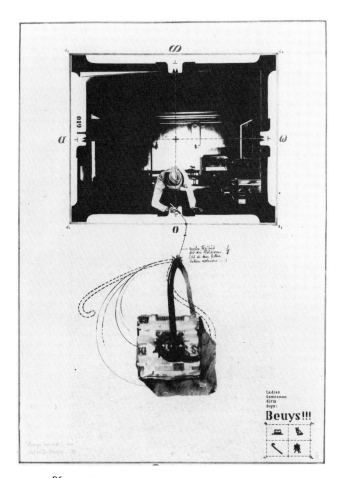

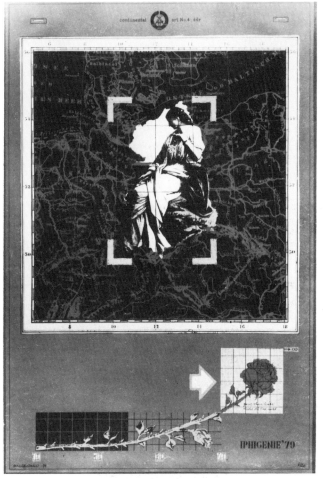

86.
Beuys Makes Light 1978
Photo-lithograph / 59 × 42

87.
Iphigenia '79 (continental art no.4) 1979
Letterpress print on polyester foil / 59 × 40

WILLI SITTE

It is generally recognised that Socialist Realism is no mere stylistic formula which can simply be employed or seen in a piece of work, but rather the expression of an attitude to reality. The central tenet of this consists in tracing as closely as possible the constant changes of social bodies and the social psyche in order to find and invent valid images for them. Since reality is in a constant flux, the manifestations of realist art change constantly, too. This also implies that realism does not wear out like other 'isms' or styles, but is capable of renewing itself constantly in artists' work.

If we talk of 'diversity and breadth' in relation to Socialist Realism, then this is not in order to appear liberal, but because a 'comprehensive approach' to the complexities of life and to the diversity of the artistic needs of the public does not permit any restrictions of content or form.

From speech at the
IX. Congress of the Artists' Union of the GDR,
1983

91.
The Victors 1972
Oil on hardboard
270 × 165
Gallery of Fine Art, Rostock

Painter and graphic artist.
1921 Born in Kratzau (Chrastava) Czechoslovakia.
1936–39 Studied at Art College of North Bohemian Museum of Crafts, Reichenberg (Liberec).
1939–40 Studied with Werner Peiner at Master School of Monumental Painting, Kronenburg/Eifel.
1941–44 Military service.
1944 Joined Italian partisans.
1945–45 Freelance work, Milan.
1947 Moved to Halle/Salle, founder member of art group *Die Fähre* (The Ferry).
1951- Lecturer at Department of Fine and Applied Arts, School of Industrial Design, Halle, Schloss Giebichenstein.
1959– Appointed Professor.
1972– Appointed Director.
1969 Appointed Member of Academy of Arts of GDR.
1974– President of Artists' Union of GDR.
 Lives in Halle.

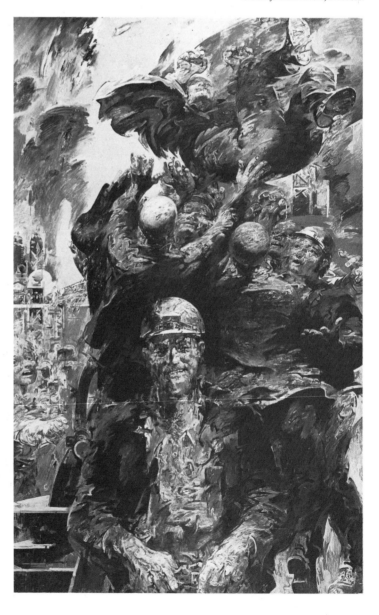

93.
Self-portrait with Brush 1981
Oil on hardboard
125 × 80

94.
Couple on White Sheet 1982
Oil on hardboard
127 × 172
Museum of Fine Arts, Leipzig
Illustrated in colour p.13

95.
In the Witness Box 1972
Study for '*Everyone has the Right to Live and to be Free*'
Pen, brush, coloured inks
95 × 75

97.
My Mother – End 1974
Pen, brush, ink, sepia, wash
98 × 75

98.
Study for 'The Red Flag –Struggle, Grief and Victory' 1974
Pen, brush, ink, sepia
95 × 75

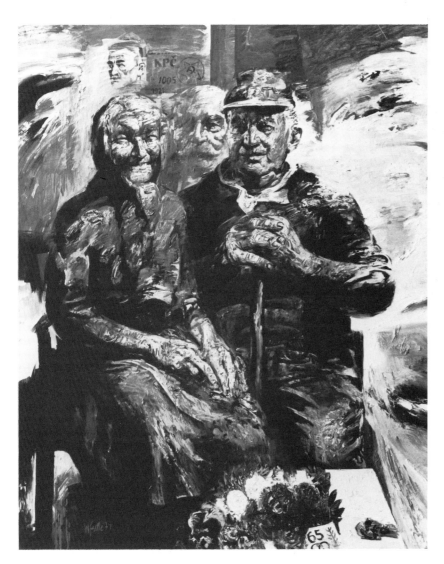

92.
My Parents 1974
Oil on hardboard
170 × 140

96.
Sauna in Volgograd II 1972
Pen, brush, ink, sepia
95 × 75

99.
Study of Workers 1977
Pen, brush, ink, sepia
99.5 × 75

VOLKER STELZMANN

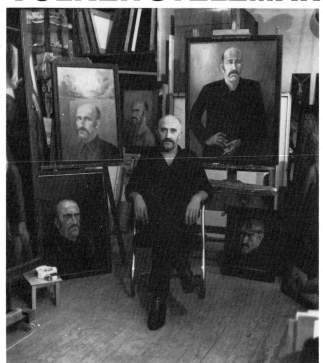

101.
Sitting Figure 1983
Mixed technique on hardboard
90.5 × 70.5

102.
Transformation 1983
Mixed technique on hardboard
88 × 91

Painter and graphic artist.
1940 Born in Dresden.
1949 Moved to Leipzig.
1957–63 Apprenticeship and work as mechanic, at same
 time attended evening school of School of
 Graphic Art and Printing Design, Leipzig.
1963–68 Studied with G.K. Müller, Harry Blume, and
 Hans Meyer-Foreyt at School of Graphic Art
 and Printing Design, Leipzig.
1968– Freelance.
1973–75 Probationary period as university teacher.
1975– Full lecturer at the School of Graphic Art of
 Printing Design, Leipzig.
1982 Appointed Professor.
 Lives in Leipzig.

104.
Likeness of Friedel Fischer 1983
Mixed technique on hardboard
90 × 65

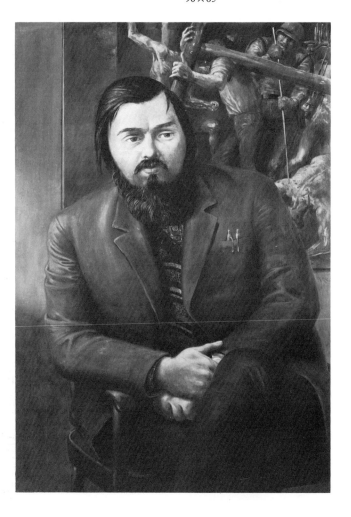

105.
Carnival II 1979
Pencil, pen, ink wash
48 × 65.4

106.
Carnival IV 1979
Pen, ink wash
38.8 × 48

107.
Apocalypse I 1982
Pencil, pen, ink wash
48 × 65.5

108.
Apocalypse II 1982
Pencil, pen, ink, water colour, coloured crayon
66 × 48

100.
Investigation 1976
Triptych. Mixed technique on hardboard 180 × 125/180 × 78/180 × 78
Centre for Art Exhibitions of the GDR

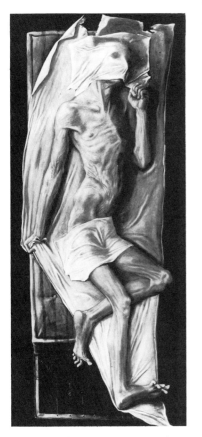
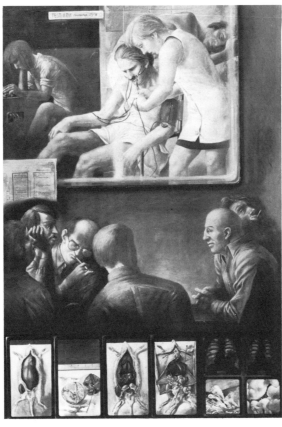
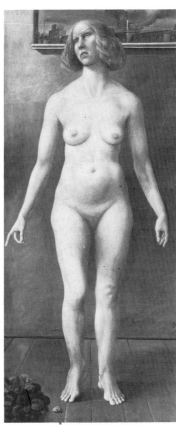

103.
Likeness of Frau Annegret 1983
Mixed technique on hardboard
80 × 60

DAGMAR STOEV

I prefer an expressive, vehement, even brusque manner of painting, because the origin of my visual ideas is more rooted in emotional experience than in abstract associations. I am mainly interested in the human figure, especially in heads. Models are important mediators for my experiences of reality, for human possibilities. Spontaneity, my own frame of mind, a fear of not coming up to expectations, and my liking for colour, determine the actual picture. The carriers of expression are largely colour and the manner in which the paint is handled, rather than the exact drawing of attributes or gestures. Since I perceive my surroundings as full of contradictions and changes it is natural that my paintings avoid facile optimism and conventional beauty. My motivation for painting is the wish to express my approach to life visually, and to move others, possibly even to make them more receptive.

Painter.
1957　　Born in Dresden.
1972–76　Attended evening school at the School of Fine Arts, Dresden.
1976–78　Studied at School of Fine Arts, Dresden.
1978–81　Studied with Bernhard Heisig at School of Graphic Art and Printing Design, Leipzig.
1981–　　Freelance.
　　　　　Lives in Leipzig.

110.
Self-portrait with Flower 1983
Oil on canvas
90 × 70
Illustrated in colour p.24

111.
The Cableway 1983
Oil on hardboard
70 × 100

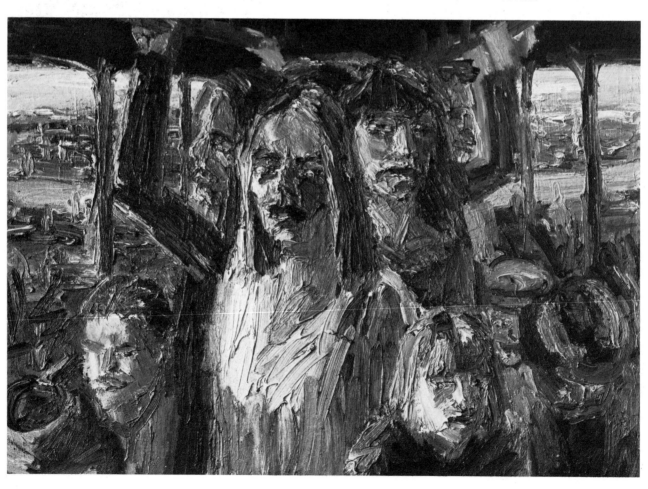

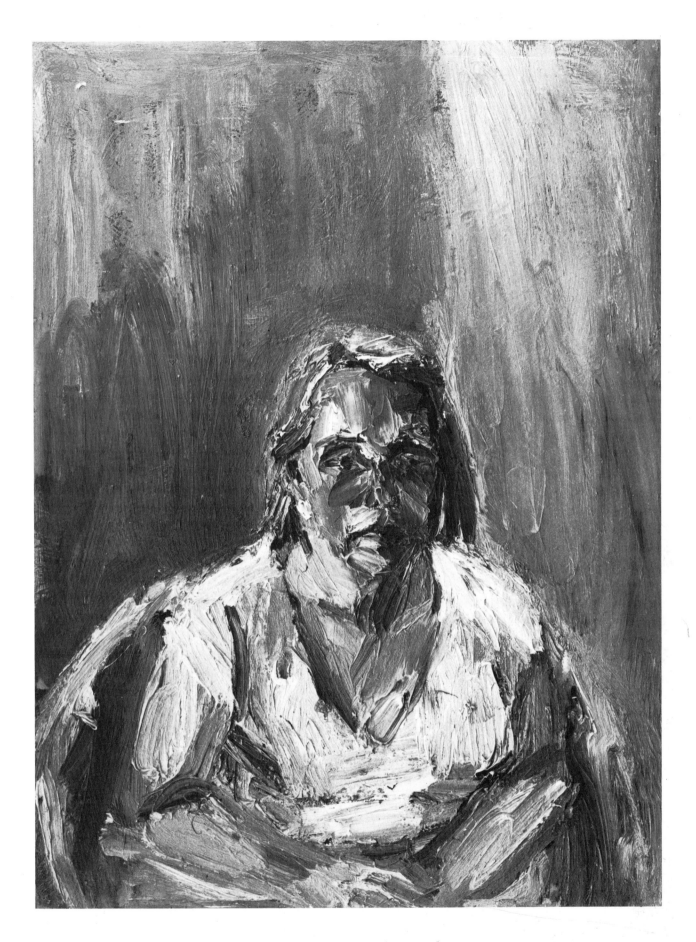

109.
Portrait of my Mother 1981
Oil on hardboard
120 × 90

WERNER TÜBKE

My decisive starting point is and was the study of nature. Not side by side or in addition, but in immediate connection to this I strive to use periods of realism in the history of art and to make them come alive . . . I feel embedded in the axis of time in the most natural manner. Since however the study of nature and the study of art, are so extraordinarily close, at times identical, I am lacking all sense of historical distance. Because of this historical topics are not historical for me, and I can treat them as if they were current, very personal events of today. If this was not the case, then I could not have spent so many years working with intense enjoyment on the theme of *Early Bourgeois Revolution in Germany*. All the nuances of my feelings about the world slide perfectly unselfconsciously into the work . . .

As professional realists we have some important tasks, such as deepening the possibilities for depicting the human image, appreciating the dignity of human beings (and showing them not only as insecure, fearful and stuttering). We must find plausible, convincing fables to convey fundamental human behaviour, and so on. History? Of course, there is nothing else except history. (From an interview with Detlev Lücke, 1982)

112.
Sicilian Estate Owner with Puppets 1972
Oil on wood
80 × 170
National Art Collection Dresden, Gallery of
Modern Masters
Illustrated in colour p.ii

113
Destroyed Doll 1980
Mixed technique on wood
99 × 69

116.
The Last Judgment from **The Early Bourgeois Revolution in Germany** 1983
Oil on canvas
198 × 299
Illustrated p.30

1929 Born in Schönebeck/Elbe
1945–47 Apprenticeship as painter and decorator, then attended Master School of German Trades at Magdeburg.
1948–49 Studied with Elizabeth Voigt and Ernst Hassebrauk at School of Graphic Art and Printing Design, Leipzig.
1950–53 Studied Art Education and Psychology at Ernst Moritz Arndt University, Greifswald.
1953–54 Assistant lecturer at the Centre of National Art, Leipzig.
1954– Freelance.
1956–57 Lecturership at College of Graphic Art and Printing Design, Leipzig.
1963– Worked as university teacher in the Leipzig Art School.
1965 Appointed Reader.
1972 Appoined Professor.
1973–76 Director.
1976– Start of work on large-scale panoramic mural on the subject of the early bourgeois revolution for the Memorial to the Peasants' Uprising (1525) at Bad Frankenhausen.
1982 Appointed Member of Royal Academy of Arts, Stockholm.
1983 Appointed Member of Academy of Art of the GDR.
 Lives in Leipzig and Bad Frankenhausen.

115.
Three Women from Cefalu 1983
Oil on canvas
150 × 150

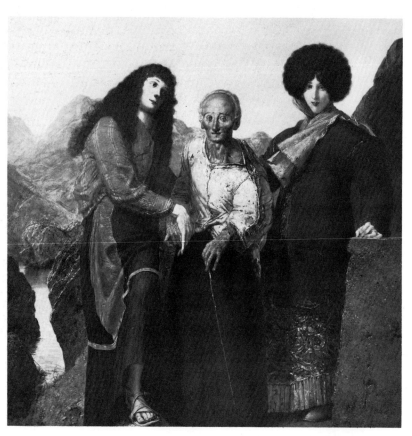

114.
Death in the Mountains (with self-portrait)
1982
Oil on canvas
300 × 200

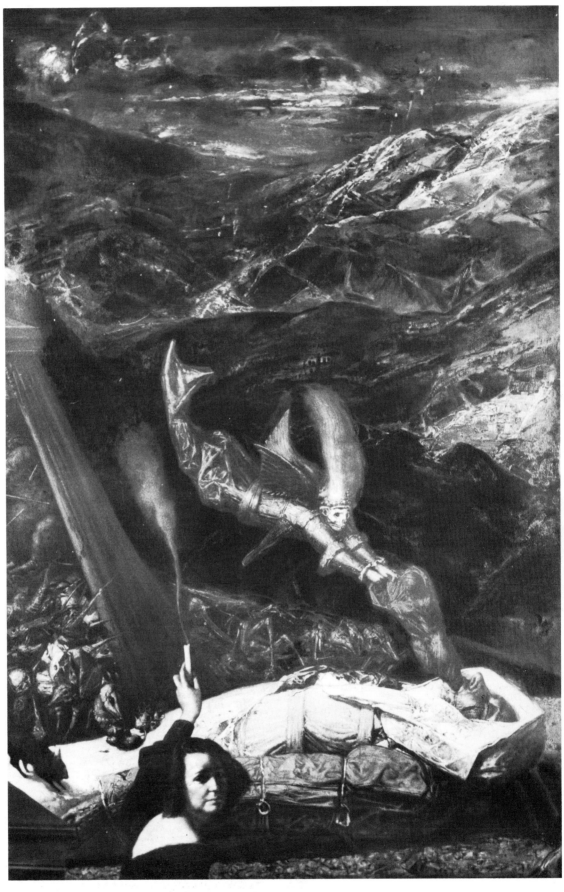

SELECTED EXHIBITIONS AND BIBLIOGRAPHY

GUDRUN BRÜNE:

First solo exhibition in Leipzig, **Contemporary Art,** 1973. Since 1966 has participated in important exhibitions in GDR and abroad, including **Visual Art in the GDR,** 1974, Hall of Art, Helsinki, and Alvar Aalto Museum, Jyväskylä; **Man and World: Painting and Graphic Art in the GDR,** Künstlerhaus, Bethanien, West Berlin 1980; **Dialogue: Painting, Graphic Art, Sculpture,** Warsaw, 1980; **Man and World: Painting and Graphic Art in the GDR,** Dalles Hall, Bucharest, 1980–81; **'Painting and Graphic Art in the GDR',** Vienna Secession, 1981–82; **'Tradition and Renewal',** Academy of Art, Stockholm, 1983.

Renate Hartleb: *Künstler in Leipzig,* Berlin 1976 (Welt der Kunst); | Günter Meißner: *Leipziger Künstler der Gegenwart,* Leipzig 1977; | Ingrid Beyer (ed.): *Junge Künstler im Sozialismus,* Berlin 1978; | *Gudrun Brüne, Malerei und Grafik,* catalogue, Galerie Sozialistische Kunst am Bezirksmuseum Potsdam, 1978 (text: Ina Gille) | Catalogue, *Weggefährten – Zeitgenossen,* Altes Museum, Berlin 1979 | Catalogue, *Tradition och förnyelse: Elva målare från DDR,* Konstakademien, Stockholm 1983 (text: Renate Hartleb.)

CARLFRIEDRICH CLAUS:

First solo exhibition in GDR at Magdeburg, Otto von Guericke Club 1968. Represented at VIII. National Exhibition of Art, 1977/78, and at IX. National Exhibition of Art, Dresden, 1982/83. Has participated in international exhibitions since 1961, including: **Schrift en Beeld,** Stedelijk Museum, Amsterdam, 1963; **Writing and Painting,** Staatliche Kunsthalle, Baden-Baden, 1963; **Graphica Creativa,** Jyvaskylä, 1978; **5th International Biennale of Drawing,** Wroclav, 1978; **7th International Biennale of Drawing,** Craców, 1978; **8th International Biennale of Drawing,** Craców, 1980; **Painting and Graphic Art in the GDR,** Musée d'Art Moderne, Paris, 1981; **Zeitvergleich: Painting and Graphic Art in the GDR,** touring exhibition throughout West Germany, 1982/84; **Graphic Art in the GDR: Cycles and Sequences,** Nikolaj Exhibition Centre, Stockholm, 1983.

Dietrich Mahlow: *Schrift und Bild,* catalogue, Frankfurt/Main 1963 | Will Grohmann (ed.): *Kunst unserer Zeit. Malerei und Plastik,* 1966 | Thomas Dehner: Carlfriedrich Claus, in *Von der Collage zur Assemblage,* Nuremberg 1968 | Franz Mohn: 'Carlfriedrich Claus', in *Was die Schönheit sei... Künstler-Theorie Werk.* Catalogue, II Biennale, Kunsthalle Nuremberg, Cologne 1971 | Catalogue, *Zeichnungen in der Kunst der DDR,* Kupferstichkabinett, Dresden 1974 | *Carlfriedrich Claus,* catalogue Galerie Arkade, Berlin 1975 (texts: Werner Schmidt, Gerhard Wolf et al, with list of exhibitions and bibliography) | G.J.de Rock (ed.): *Anthologie visuele poezie, Visual Poetry Anthology,* Den Haag 1975 | Henry Schumann: *Ateliergespräche,* Leipzig 1976 | Albert Kapr: *Ästhetik der Schriftkunst,* Leipzig 1977 | Lothar Lang: 'Zur Auroramappe', in *Marginalien,* 4, 1978 | Lothar Lang: *Malerei und Graphik in der DDR,* Leipzig 1978 | Gerhard Wolf: 'In eigener Sprache schreiben: Carlfriedrich Claus und seine Sprachblätter', in Joachim Walter (ed.): *Mir scheint, der Kerl lasiert: Dichter über Maler,* Berlin 1978 | *C.Claus, Sprachblätter,* K. Sobolewski, *Bilder,* catalogue, Galerie Clara Mosch, Karl-Marx-Stadt 1979 | *Carlfriedrich Claus, Sprachblätter,* catalogue, *Erwerbungen 36,* Kupferstichkabinett, Dresden 1980 (text: Werner Schmidt) | Karin Thomas: *Die Malerei in der DDR, 1949–1979,* Cologne 1980 | Carl Vogel: 'Carlfriedrich Claus', in *Zeitvergleich: Malerei und Grafik aus der DDR,* Hamburg 1982 (with list of exhibitions and bibliography).

HARTWIG EBERSBACH:

First substantial solo exhibition, Staatliches Lindenau-Museum, Altenburg, 1982. Since 1965 has participated in the Leipzig area art exhibitions, and in exhibitions abroad, including: **Painting and Graphic Art in the GDR,** Musée d'Art Moderne, Paris, 1981; **Zeitvergleich: Painting and Graphic Art in the GDR,** touring exhibition throughout West Germany, 1982/84; **Self-Portraits of Artists from the GDR,** Ernst Museum, Budapest, 1983.

Günter Meißner: *Leipziger Künstler der Gegenwart,* Leipzig, 1977 | Lothar Lang, *Malerei und Graphik in der DDR,* Leipzig 1978 | Karl H. Lötzer: 'Kunst in Leipzig', in *tendenzen* 131, 1980 | Friedrich Schenker: 'Zum "Kammerspiel II – missa nigra"', in *FZO, Festival des politischen Liedes,* Berlin, *Tageszeitung,* 9 February 1980 | Karin Thomas: *Die Malerei in der DDR 1949–1979,* Cologne 1980 | *Gedanken bildender Künstler vor dem X. Parteitag der SED und zur Vorbereitung auf die IX. Kunstausstellung der DDR in Dresden* | 'Hartwig Ebersbach', in *Bildende Kunst,* 3, 1981 | *Hartwig Ebersbach,* pamphlet, Galerie West, Dresden 1981 | *Hartwig Ebersbach,* catalogue, Galerie oben, Karl-Marx-Stadt 1982 (text: Claus Baumann) | *Hartwig Ebersbach, Malerei,* catalogue, Staatliches Lindenau Museum, Altenburg 1982 (text: Jutta Penndorf and own statements) | Tilmann Osterwald: 'Hartwig Ebersbach', in *Zeitvergleich: Malerei und Grafik aus der DDR,* Hamburg 1982 (with list of exhibitions and bibliography).

HUBERTUS GIEBE:

First solo exhibition, Galerie Comenius, Dresden, 1980. Since 1978 has participated in numerous exhibitions in the GDR and abroad, amongst them: **European Triennial of Etching,** Grado, 1981; **5th Indian Triennial,** New Delhi, 1982; **8th International Exhibition of Drawings,** Rijeka, 1982; **IX. National Exhibition of Art,** Dresden, 1982–83; **Graphic Art in the GDR: Cycles and Sequences,** Nikolaj Exhibition Centre, Copenhagen, 1983; **15th International Biennale of Graphic Art,** Ljubljana, 1983; **10th Baltic Biennale,** Rostock, 1983; **Young Artists in the Soviet Union and the GDR,** Moscow, 1983.

Eva Strittmatter: 'Hubertus Geibe', in Joachim Walter (ed.): *Mir scheint, der Kerl lasiert: Dichter über Maler,* Berlin 1978 | *Hubertus Giebe,* pamphlet, Galerie Comenius, Dresden 1978 (text, Diether Schmidt) | *Hubertus Giebe,* pamphlet, Damastmuseum, Großschönau 1981 | Diether Schmidt: 'Weg vom schönen Schein ästhetischer Wohligkeit', in catalogue, *Junge Dresdner Kunst,* Verband Bildender Künstler Dresden, 1981 | Gabriele Muschter: 'Bewegung und Totenstille', in: *Bildende Kunst,* 7, 1981 | *Hubertus Giebe, Zeichnungen, Druckgrafik,* pamphlet, G.-W. Leibnitz-Klub, Leipzig 1982 (text: Henry Schumann) | Reinhardt Grahl: 'Schönheit zwischen Schein und Schock: die Bildwelt des Hubertus Giebe', in *Sonntag* 11, 1983 | *Hubertus Giebe,* pamphlet, Studio Galerie, Berlin 1983 (text: Christoph Tannert).

SIGHARD GILLE:

First solo exhibition, Bilderkabinett, Leipzig 1969. Since 1972 has participated in important exhibitions in the GDR and abroad, including: **Contemporary Visual Art in the GDR,** touring exhibition throughout Czechoslovakia and Soviet Union, 1973; **Painting and Miniature Sculpture in the GDR,** 1975, France; **Visual Art in the GDR,** Kulturhaus at Sörgelstorg, Stockholm, and Künstlerhaus, Oslo, 1976; **Young Artists in the GDR,** Portugal, 1976; **Painting and Graphic Art in the GDR,** Kunsthalle Friedrich Netzel, Worpswede, 1976; **'As a Good Realist I Have to Invent Everything':** **International Realism Today,** Kunstverein, Hamburg, 1978–79; **Man and World: Painting, Graphic Art, Sculpture in the GDR,** 1980, Künstlerhaus Bethanien, West Berlin, 1980; **Painting and Graphic Art in the GDR,** Vienna Secession, 1981–82; 40th Venice Biennale, 1982; **Zeitvergleich: Painting and Graphic Art in the GDR,** 1982/84, touring exhibition throughout West Germany, 1982–84; **Self-portraits of Artists in the GDR,** Ernst Museum Budapest, 1983; **Tradition and Renewal: 11 painters from the GDR,** Academy of Art, Stockholm, 1983.

Wolfgang Hütt: *Wir – unsere Zeit,* Berlin 1974 | Günter Blutke: 'Streben nach Lebenswahrheit', in *Bildende Kunst,* 1, 1976 | *Sighard Gille,* pamphlet, Klubgalerie der Intelligenz, Leipzig 1976 (Text: Karl Max Kober) | *Sighard Gille,* pamphlet, Berlin, 1977 (Text: Günter Blutke) | *Malerei und Grafik der DDR,* catalogue, Kunsthalle Friedrich Netzel, Worpswede 1978 (text: Günter Blutke) | Renate Hartleb: *Künstler in Leipzig,* Berlin 1976 | Günter Blutke: 'Der springende Punkt: über Bildfindung und -aussage, Sonntag sprach mit Sighard Gille', in: *Sonntag,* 47, 1977 | Günter Meißner: *Leipziger Künstler der Gegenwart,* Leipzig 1977 | Raimund Hoffmann: 'Ausstellung Sighard Gille, Malerei und Grafik, Galerie Berlin', in *Mitteilungen des Verbandes Bildender Künstler* 3, 1977 | Uwe Schneede: *Als guter Realist muß ich alles erfinden,* Hamburg 1978 | Ingrid Beyer (ed.): *Junge Künstler in Sozialismus,* Berlin 1978 | Wolfgang Hütt: *Grafik in der DDR,* Dresden 1979 | Catalogue, *Weggefährten – Zeitgenossen,* Altes Museum, Berlin 1979 | Karin Thomas: *Die Malerei in der DDR 1949–1979,* Cologne 1980 | Karl Max Kober: 'Furioses Klangfeld: Sighard Gilles Deckengemälde "Lied von der Erde" im Gewandhaus Leipzig', in: *Bildende Kunst,* 9, 1982 | Uwe M. Schneede: 'Sighard Gille, in: *Zeitvergleich – Malerei und Grafik aus der DDR,* Hamburg 1982 (with list of exhibitions and bibliography | *Sighard Gille, Malerei und Grafik,* catalogue, Staudenhof Galerie, Potsdam 1983 (text: Wally Poltiniak) | *Tradition och förelse: Elva målare från DDR,* catalogue Konstakademien, Stockholm 1983 (text: Renate Hartleb)

BERNHARD HEISIG:

Important solo exhibitions: Museum of Fine Arts, Leipzig, 1966; National Art Galleries, Dresden, Modern Masters; Museum of Fine Arts, Leipzig; Staatliche Museen, East Berlin, 1972–74; Palace of Culture, Poznan, 1976; Galerie Hertz, Bremen; Kunstverein, Frankfurt/Main, 1980; Galerie Brusberg, Hanover, 1981.

Since 1952 he has participated in many important exhibitions in the GDR and abroad, including: **Thirty Victorious Years,** International Exhibition of Art at Moscow, Berlin, Prague, Sofia, Plovdiv, Bucharest, Budapest, Warsaw, Havana, Ulan-Bator, 1975; **'Painting, Graphic Art, Sculpture in the GDR,** Majakovski Galerie, West Berlin, 1975; **Visual Art in the GDR,** Kulturhaus at Sörgelstorg, Stockholm, and Künstlerhaus, Oslo, 1976; **International Exhibition of Art,** Belgrade, 1977; **documenta 6,** Kassel, 1977; **Graphica Creativa,** Jyväskylä, 1978; **Art in the GDR,** Kunsthalle Friedrich Netzel, Worpswede, 1978; **'As a Good Realist I Have to Invent Everything': International Realism Today,** Kunstverein, Hamburg, 1978–79; **Art Today in the GDR,** Neue Galerie, Sammlung Ludwig, Aachen, 1979; **Three Artists from the GDR: Bernard Heisig, Harald Matzkes, Werner Tübke',** Konstmuseum, Göteborg, 1979; **Art 12/81,** Kunstmesse, Basle, 1981; **Painting and Graphic Art in the GDR,** Musée d'Art Moderne, Paris, 1981; **Painting and Graphic Art in the GDR,** Vienna Secession, 1982; **Zeitvergleich: Painting and Graphic Art in the GDR,** touring exhibition throughout West Germany, 1982/84; **Art 14/83,** Kunstmesse Basel, 1983; **Graphic Art in the GDR: Cycles and Sequences,** Nikolaj Exhibition Centre, Copenhagen, 1983.

Günter Meißner: 'Architekturbezogen und originell', in: *Bildende Kunst,* 10, 1965 | Günter Meißner: 'Um die Vertiefung realistischer Aussage' in *Bildende Kunst,* 2, 1966 | Harald Olbrich: 'Voll schöpferischer Unrast: zum Schaffen des Leipziger Malers Bernhard Heisig,' in *Bildende Kunst,* 1, 1972 | Karl Max Kober: 'Von der Chance, an einem Weltbild mitzuarbeiten: Zu Bernhard Heisigs Bildern über die Pariser Kommune,' in *Bildende Kunst,* 9, 1972 | *Bernhard Heisig,* catalogue, Dresden and Leipzig 1973 (with list of paintings, text: Karl Max Kober) | Catalogue, *Zeichnungen in der Kunst der DDR,* Kupferstichkabinett, Dresden 1974 | Renate Hartleb: *Bernhard Heisig,* Dresden 1975 (Maler und Werk) | Lothar Lang, in catalogue, *documenta 6,* Kassel 1977 | *Bernhard Heisig,* catalogue, Kulturhistorisches Museum Magdeburg, 1978 (text: Karl Max Kober) | 'Selbstzeugnisse: Gespräch zwischen Bernhard Heisig und Norbert Stratmann', in *tendenzen,* 104, 1975, | Henry Schumann: *Ateliergespräche,* Leipzig 1976 | Catalogue, *Weggefährten – Zeitgenossen,* Altes Museum Berlin, 1979 | Karl Max Kober: 'Bernhard Heisig', in: *Künstler der DDR,* Dresden 1981 (with bibliography) | Karl Max Kober: *Bernhard Heisig,* Dresden 1981 (with bibliography) | *Bernhard Heisig, Gemälde und Druckgraphik,* catalogue, Staatliches Museum Schloss Burgk/New Gallery, 1981 | *Bernhard Heisig: Bilder aus den siebziger Jahren,* pamphlet, Galerie Michael Hertz, Bremen 1981 | Peter Sager: 'Der alte Wilde', in *Zeitmagazin,* Hamburg, 13, 1982 | Peter M. Bode: 'Bernhard Heisig,' in *Zeitvergleich: Malerei und Grafik aus der DDR,* Hamburg 1982 (with list of exhibitions and bibliography).

GERHARD KETTNER:

Important solo exhibitions: Central Bookshop Gallery, (with Werner Stötzer), Vienna, 1965; Museum of Fine Arts, Leipzig, 1966; Neue Münchner Galerie, Munich, 1970; Kupferstichkabinett, Staatliche Museen, Berlin, 1977; Galerie Junge Kunst, Frankfurt/Oder, 1977; Repin Institute, Leningrad, 1979; Galerie Döbler, Ravensburg, 1982.

Since 1955 regular participation in major exhibitions in the GDR and significant exhibitions abroad, amongst them: **Twelve Artists from the GDR,** Galleria la Colonna, Milan, 1958; **Fine Art in Socialist Countries,** Moscow, 1958; **Art from Dresden,** Kassel, 1964; **Staff of the School of Fine Arts at Dresden,** Coventry, 1966; **'International Biennale of Graphic Art,** Ljubljana, 1969; **2nd International Biennale of Graphic Art,** Florence, 1970; **3rd Indian Triennial,** New Delhi, 1971; **3rd International Biennale of Graphic Art,** Frechen, 1972; International Prize of Graphic Art, Biella, 1973; **International Biennale of Graphic Art,** Ljubljana, 1973; **'Contemporary Art in the GDR',** Gallery, Tokuma, Tokyo, 1973; **3rd International Biennale of Graphic Art,** Wroclav, 1974; **International Exhibition of Drawing,** Rijeka, 1974; **4th International Biennale of Graphic Art,** Frechen, 1974; **Water colours and Drawings,** National Gallery, Prague, 1978; **Art from the GDR,** Kunsthalle Friedrich Netzel, Worpswede, 1980; **Art from the GDR,** Teatro del Falcone Gallery, Genoa, 1980; **Art 11/80,** Kunstmesse, Basle; **Painting and Graphic Art in the GDR,** Kunstzentrum, Dresden, 1980; Galerie Döbele, Ravensburg, 1980; **Painting and Graphic Art in the GDR,** Musée d'Art Moderne, Paris, 1981; Artists from the GDR, Century Hall, Hoechst, 1981; **Painting and Graphic Art in the GDR,** Vienna Secession, 1981/82; **Zeitvergleich, Painting and Graphic Art in the GDR,** Touring Exhibition throughout West Germany, 1982/84; **Hans Theo Richter and His Pupils,** Austria House, Vienna, 1984.

Lothar Lang: 'Über einige Arbeiten Gerhard Kettners,' in *Bildende Kunst*, 4, 1959 | Diether Schmidt: 'Um Meisterschaft bemüht, Gerhard Kettner, der Zeichner', in: *Bildende Kunst*, 7, 1964 | Werner Schade: 'Gerhard Kettner,' in *Weggefährten: 25 Künstler der DDR*, Dresden 1970 | Catalogue, *Zeichnungen in der Kunst der DDR*, Dresden 1974 | *Gerhard Kettner: Zeichnungen und Lithographien*, Catalogue, Staatliche Museum, Berlin 1977 (with list of lithographs, text: Werner Schade) | Werner Ballarin: 'Eigener Auftrag und spezifische Mittel im Schaffen Gerhard Kettners', in *Bildende Kunst*, 26, 1979 | Wolfgang Hütt: *Grafik in der DDR*, Dresden 1979 | Karin Thomas: *Die Malerei in der DDR 1949–1979*, Cologne 1980 | *Malerei und Grafik aus der DDR*, Kunstzentrum Dresden, Galerie Döbele, Ravensburg 1980 | Diether Schmidt: 'Gerhard Kettner', in *Künstler der DDR*, Dresden 1981 (with bibliography) | *Gerhard Kettner: Zeichnungen und Lithographien*, catalogue, Galerie Döbele, Ravensburg 1982 (text: Camilla Blechen) | Reinhard Müller–Mehlis: 'Dresdner Kontinuität', in *Weltkunst*, 4, 1982 | Ulrich Krempel: 'Gerhard Kettner', in *Zeitvergleich: Malerei und Grafik aus der DDR*, Hamburg 1982.

WALTER LIBUDA:

First solo exhibition, Staatliches Lindenau-Museum, Altenburg, 1980. Since 1978 has participated in exhibitions in the GDR and abroad, including: **6th International Biennale of Woodcuts and Wood Engraving,** Banska Bystrica, 1980; **6th International Biennale of Graphic Art,** Frechen, 1980; **International Biennale of Graphic Art,** Ljubljana, 1980; **Young Artists from the GDR,** Venice, 1981; Xylon, Vienna, 1981; **Paris Biennale,** 1982; **Biennale of Graphic Art,** Mulhouse, 1982; **IX. National Exhibition of Art in the GDR,** Dresden, 1982–83; **Zeitvergleich—Painting and Graphic Art in the GDR,** touring exhibition throughout West Germany, 1982/84; **Young Artists in the Soviet Union and the GDR,** Moscow, 1983; **Art 14/83,** Kunstmesse, Basle, 1983.

Gunhild Brandler: 'Walter Libuda', in *Bildende Kunst*, 9 1980 | Klaus Schrank: 'Walter Libuda', in *Zeitvergleich: Malerei und Grafik aus der DDR*, Hamburg 1982 (with list of exhibitions | Gunhild Brandler: 'Im Dickicht der Bilder: Der Maler Walter Libuda', in: *Sonntag*, 37, 1983 | *Walter Libuda*, pamphlet, Studio Galerie Berlin (text: Christoph Tannert) | *Walter Libuda*, catalogue, Galerie Peter Fischinger, Stuttgart 1983 (text: Klaus Schrenk).

WOLFGANG PETROVSKY:

First solo exhibition, Galerie Comenius, Dresden, 1979. Since 1970 has participated in several exhibitions in the GDR and abroad, including: Kunstverein, Hanover, 1980; **Painting and Graphic Art in the GDR,** Musée d'Art Moderne, Paris, 1981; **Aspects of Drawing in the GDR,** Galerie Alvensleben, Munich, 1982; **IX. National Exhibition of Art,** Dresden, 1982–83.

Collagen, Montagen, Frottagen von Künstlern der DDR, catalogue, Gallery am Sachsenplatz, Leipzig 1978 | *Wolfgang Petrovsky*, pamphlet, Galerie Comenius, Dresden 1979 (text: Diether Schmidt) | *Wolfgang Petrovsky*, pamphlet, Klubgalerie, Leipzig 1981 (Text: R.Bernhof) | Werner Ballarin: 'Geschichte differenziert gesehen', in catalogue, *Junge Dresdner Kunst*, Verband Bildender Künstler, Dresden 1981 | *Wolfgang Petrovsky, Frank Voigt*, pamphlet, Galerie Nord, Dresden 1983 (text: Bernd Rosner).

JÜRGEN SCHIEFERDECKER:

First solo exhibition, Schloss Moritzburg, Dresden, 1964. Since 1974 has participated in numerous exhibitions in the GDR and abroad, amongst them: **3rd International Biennale of Graphic Art,** Frederikstadt, 1976; **VIII. National Exhibition of Art,** Dresden, 1977–78; **5th International Biennale of Graphic Art,** Cracow, 1978; **6th International Biennale of Graphic Art,** Florence, 1978; **5th International Biennale of Graphic Art,** Frechen, 1978; **Graphic Art in Colour in the GDR,** touring exhibition: Cracow, Mielca, Warsaw, Havana, 1978–79; Galerie Narodna, Ljubljana, 1978; **International Prize of Graphic Art,** Biela, 1979; **International Biennale of Graphic Art,** Tokyo, 1979; **6th International Biennale of Graphic Art,** Frechen, 1980; **8th International Biennale of Graphic Art,** Cracow, 1980; **Painting and Graphic Art in the GDR,** Musée d'Art Moderne, Paris, 1980; **2nd European Biennale,** Baden-Baden, 1981; **Contemporary Graphic Art in the GDR,** Museum of Modern Art of the World, Kali, 1982; **Graphic Art in the GDR: Cycles and Sequences,** Nikolaj Exhibition Centre, Copenhagen, 1983.

Jürgen Schieferdecker, pamphlet, Kunstkaten Ahrenshoop 1973 | *Jürgen Schieferdecker*, pamphlet, Galerie Kühl, Dresden 1976 | Catalogue, *Jürgen Schieferdecker: Gemälde, Assemblagen, Zeichnungen, Grafik*, Dresden 1978 | Lothar Lang: *Malerei und Grafik in der DDR*, Leipzig 1978 | *Von der Collage zur Assemblage: Aspekte der Materialkunst in der DDR*, catalogue, Nationalgalerie Berlin 1978 | Wolfgang Hutt: *Grafik in der DDR*, Leipzig 1978 | *Jürgen Schieferdecker: Gemälde, Assemblagen, Zeichnungen, Graphik*, catalogue, Stadtmuseum Zittau, 1979 (text: Jürgen Schweinebraden) | Catalogue, *Weggefährten – Zeitgenossen*, Altes Museum, Berlin 1979 | Catalogue, *Jürgen Schieferdecker: Grafik, Collagen*, Klub der Intelligenz 'Pablo Neruda', Karl-Marx-Stadt 1981 | Gotthard Brandler: 'Engagement und Experiment: über Jürgen Schieferdecker', In *Bildende Kunst*, 6, 1982 | *Jürgen Schieferdecker, Grafik, Collagen*, pamphlet, Gallery im Friedländer Tor, Neubrandenburg 1983 (text: Ingrid Wenzkat).

WILLI SITTE:

Important solo exhibitions: Staatliche Galerie Moritzburg, Halle, 1971; Kunsthalle, Rostock, 1971; Nationalgalerie, East Berlin, 1972; Exhibition Centre of Artists' Union of Soviet Union, Moscow, 1972; Lalit Kala Academy, New Delhi, 1973; Tokyo, 1973; Kunstverein, Hamburg, 1975; Hall of Art, Lund, 1976; Centre of Artists' Union of Soviet Union, Moscow, 1981; Galerie Michael Hertz, Bremen, 1982; Ulan-Bator, 1982; Staatliche Kunsthalle, West Berlin, 1982; Künstlerhaus, Vienna, 1984.
Since 1964 has participated in many important exhibitions in the GDR and abroad, amongst them: **German Socialist Art: Painting, Graphic Art, and Sculpture in the GDR,** Ernst Museum, Budapest, National Gallery, Bucharest, 1964; International Art Exhibition, 5th Congress of AIAP (International Association of Artists), Tokyo, 1966; Ars Baltica, Visby, 1970; **Graphic Art of Ten Artists from the GDR,** Künstlerhaus, Oslo, 1970; **Against Fascism and War: Art Exhibition of Socialist Countries,** Warsaw, 1970; **3rd International Biennale of Graphic Art,** Florence, 1972; **Contemporary Art in the GDR,** touring exhibition through Soviet Union and Czechoslovakia, 1973; **1st Triennial of Committed Realist Art,** Sofia, 1973; **Fine Art in the GDR,** Konsthalle, Helsinki & Alvar Aalto Museum, Jyväskylä, 1974; **Thirty Victorious Years, International Art Exhibition,** Moscow, Berlin, Prague, Sofia, Plovdiv, Bucharest, Budapest, Warsaw, Havana, Ulan-Bator, 1975; **Art from the GDR,** Kulturhaus at Sörgelstorg, Stockholm, and Künstlerhaus, Oslo, 1976; **2nd International Triennial of Socialist Painting,** Sofia, 1976; **documenta 6,** Kassel, 1977; **4th Indian Triennial,** New Delhi, 1978; **Painting and Graphic Art in the GDR,** Kunsthalle Friedrich Netzel, Worpswede, 1978; **Art Today in the GDR,** Neue Galerie, Sammlung Ludwig, Aachen, 1978; **Art from the GDR: The Halle Region,** Kunstverein, Hanover, 1979; **Art from the GDR,** Galleria Teatro del Falcone, Genoa, 1980; **Art from the GDR,** Musée d'Art Moderne, Paris, 1981; **Painting & Graphic Art from the GDR,** Vienna Secession, 1981; **Art 13/82,** Kunstmesse Basel, 1982; **Zeitvergleich: Painting and Graphic Art in the GDR,** touring exhibition throughout West Germany, 1982/84.

Wolfgang Hütt: *Junge bildende Künstler der DDR*, Leipzig 1965 | Peter H. Feist: 'Mensch, Ritter, Tod and Teufel', in *Bildende Kunst* 5/1971 | Catalogue, Kunsthalle Rostock 1971 (Text: Hermann Raum) (with list of paintings to date) | Ingrid Schulze: Zur Problematik von Neuerertum und Erberezeption im Schaffen Willi Sittes. in: *Bildende Kunst* 10/1972 | Wolfgang Hütt: *Willi Sitte*, Dresden 1972 (with an extensive bibliography) | Peter H. Feist: 'Von Vietnam bis Chile: Zu Willi Sittes neuem Tryptichon', in: *Bildende Kunst*, 12, 1974 | Catalogue, *Zeichnungen in der Kunst der DDR*, Kupferstichkabinett, Dresden 1974 | *Willi Sitte: Gemälde und Zeichnungen 1950–74*, catalogue, Kunstverein Hamburg 1975 (Texte: Uwe M. Schneede und Hermann Raum) | Hermann Raum: 'Überlebende, Rufende, Lachende und Sieger', in *tendenzen*, 101, 1975 | Peter Sager: *Neue Formen des Realismus*, Cologne 1975 | Wolfgang Hütt: *Willi Sitte*, Dresden 1976 (Maler und Werk) | Catalogue, *documenta 6*, Kassel 1977 (text: Lothar Lang) | Wolfgang Hütt: *Künstler in Halle*, Berlin 1977 | Catalogue, Aachen Neue Galerie – Sammlung Ludwig 1979 | Catalogue, *Weggefährten – Zeitgenossen*, Altes Museum, Berlin 1979 | *Kunst aus der DDR – Bezirk Halle*, Kunstverein Hannover 1979–80 | Karin Thomas: *Die Malerei in der DDR 1949 – 79*, Cologue 1980 | *Willi Sitte, Malerei, Grafik, Handzeichnungen*, catalogue, Staatliche Galerie Moritzburg, Halle 1981 (text: Hermann Raum, Jürgen Scharfe) (with list of paintings 1971–1981) | Hermann Raum: 'Willi Sitte'. In *Künstler der DDR*, Dresden 1981 | Tair Salachow: 'Einheit schöpferischer Positionen: Willi-Sitte Exhibition, Moscow' in *Bildende Kunst*, 3, 1982 | *Willi Sitte 1945–1982*, catalogue, Staatliche Kunsthalle, Berlin 1982 (with extensive bibliography and list of exhibitions); Uwe M. Schneede: 'Willi Sitte', in catalogue, *Zeitvergleich: Malerei und Grafik aus der DDR*, Hamburg 1982 (list of exhibitions and bibliography).

VOLKER STELZMANN:

Important solo exhibitions: Staaliches Lindenau-Museum, Altenberg, 1957; Galleria del Levante, Milan, 1971; Nationalgalerie, East Berlin, 1972; Museum of Fine Arts, Leipzig, 1975; National Art Collections, Dresden, 1976; Museum of Fine Arts, Leipzig, 1976; Neue Berliner Galerie, East Berlin, 1976; Galerie Brusberg, Hanover, 1980; Academy of Art, Stockholm, 1984.
Since 1953 has participated in many important exhibitions in the GDR and abroad, amongst them: **Contemporary Art in the GDR**, Gallery Tokuma, Tokyo, 1972; **3rd International Biennale of Graphic Art**, Florence, 1972; **Contemporary Art in the GDR**, touring exhibition through Soviet Union and Czechoslovakia, 1973; **1st Triennial of Committed Realist Art**, Sofia, 1973; **Fine Art in the GDR**, Konsthalle, Helsinki, and Alvar Aalto Museum; Jyväskylä, 1974; **3rd International Biennale of Drawing**, Wroclav, 1974; **Painting, Graphic Art, Sculpture from the GDR**, Majakovski Galerie, West Berlin, 1975; **2nd Triennial of Socialist Painting**, Sofia, 1976; **documenta 6**, Kassel, 1977; **5th International of Graphic Art**, Frechen, 1978; **Painting and Graphic Art from the GDR**, Kunsthalle Friedrich Netzel, Worpswede, 1978; **5th International Biennale of Drawing**, Wroclav, 1978; **Art Today in the GDR**, Neue Galerie, Sammlung Ludwig, Aachen, 1979; **'Nachbilder' (In the Manner of)**, Kunstverein, Hanover, 1979; **Art of the Seventies**, Kunstverein Kaponier, Vechta 1979; **6th International Biennale of Graphic Art**, Frechen, 1980; **Art 12/81**, Kunstmesse Basel, 1981; **Painting and Graphic Art from the GDR**, Musée d'Art Moderne, Paris, 1981; **Masterpieces from 500 Years of German Art**, touring exhibition through Japan, 1981; **Art 13/82**, Kunstmesse Basle, 1982; **Zeitvergleich—Painting and Graphic Art in the GDR**, touring exhibition throughout West Germany, 1982/84; **Art 14/83**, Kunstmesse Basel, 1983; **Self-portraits of Artists from the GDR**, Ernst Museum, Budapest, 1983; **Graphic Art in the GDR: Cycles and Sequences**, Nikolaj Exhibition Centre, Copenhagen, 1983.

Renate Hartleb: 'Volker Stelzmann: ein junger Leipziger Künstler', in *Bildende Kunst*, 9, 1973 | *Junge Maler im Gespräch*, catalogue, Nationalgalerie, Berlin 1973 | *Volker Stelzmann*, catalogue, Kulturhaus, Neubrandenburg, 1974 | Renate Hartleb: *Volker Stelzmann*, Berlin 1976 (Welt der Kunst) | Günter Meißner: *Leipziger Künstler der Gegenwart*, Leipzig 1977 | Pamphlet, *Volker Stelzmann: Haynewalder Elegien*, Museum der Bildenden Künste, Leipzig 1978 (text: Rainer Behrends) | Lothar Lang: *Malerei und Graphik in der DDR*, Leipzig 1978 | *'Als guter Realist muß ich alles erfinden'*, Internationaler Realismus heute, catalogue, Kunstverein Hamburg 1978–79 | Catalogue, Aachen Neue Galerie – Sammlung Ludwig 1979; Catalogue, *Weggefährten – Zeitgenossen*, Altes Museum, Berlin 1979 | Wolfgang Hütt: *Grafik in der DDR*, Dresden 1979 | Volker Stelzmann, *Gemälde, Grafik, Zeichnungen*, catalogue Galerie im Hörsaalbau Karl-Marx-Universität Leipzig 1980 (text: Rainer Behrends) | Henry Schumann: 'Volker Stelzmann', in: *Künstler der DDR*, Dresden 1981 (with bibliography) | Uwe M. Schneede: 'Volker Stelzmann', in *Zeitvergleich: Malerei und Grafik aus der DDR*, Hamburg 1982 (with list of exhibitions and bibliography).

DAGMAR STOEV:

Represented at **IX. National Exhibition of Art**, Dresden, 1983.

Catalogue, *IX. Kunstausstellung der DDR*, Dresden 1982–83 | Christiane Müller: 'Bildnis mit Bildern', in *Sonntag*, 38, 1983.

WERNER TÜBKE:

Important solo exhibitions: Karl Marx University, Leipzig, 1980 and at Cracow, 1983. Since 1969 has participated in substantial exhibitions in the GDR and abroad, amongst them: **The Continuity of New Objectivity**, Milan, 1970; **2nd International Biennale of Graphic Art**, Cracow, 1972; **Contemporary Fine Art in the GDR**, touring exhibition through Soviet Union and Czechoslovakia, 1973; **Fine Art in the GDR**, Konsthalle, Helsinki, and Alvar Aalto Museum, Jyväskylä, 1974; **Painting, Graphic Art, Sculpture in the GDR**, Majakovsky Gallery, West Berlin, 1975; **Painting and Miniature Sculpture in the GDR**, France, 1975; **Painting and Graphic Art in the GDR**, Stedelijk Museum, Leuven, 1976; Syria, 1976; **4th International Biennale of Graphic Art**, Cracow, 1976; **Fine Art in the GDR**, Kulturhaus at Sörgelstorg, Stockholm, and Künstlerhaus, Oslo, 1976; **2nd Triennal of Realist Art**, Sofia, 1976; **Young Artists from the GDR**, Portugal, 1976; **4th Indian Triennial**, New Delhi, 1978; **Art from the GDR**, Kunsthalle Friedrich Netzel, Worpswede, 1978; **'As a Good Realist I Have to Invent Everything:' International Realism Today**, Kunstverein, Hamburg, 1978–79; **Art Today in the GDR**, Neue Galerie, Sammlung Ludwig, Aachen, 1979; **Art from the GDR**, Galleria Teatro del Falcone, Genoa, 1980; **Painting and Graphic Art in the GDR**, Musée d'Art Moderne, Paris, 1980; **Art 12/81**, Kunstmesse Basel, 1981; **5th Indian Triennial**, New Delhi, 1981; **Art 13/82**, Kunstmesse Basel, 1982; **40th Biennale**, Venice, 1982; **Painting and Graphic Art in the GDR**, Vienna Secession **Zeitvergleich: Painting and Graphic Art in the GDR**, touring exhibition throughout West Germany, 1982/84; **Tradition and Renewal: Eleven Artists from the GDR**, Academy of Art, Stockholm, 1983; **Art 14/83**, Kunstmesse, Basel, 1983; **Graphic Art in the GDR: Cycles and Sequences**, Nikolaj Exhibition Centre, Copenhagen, 1983.

Lothar Lang: 'Tübkes Zeichnungen und die Lust am Erkennen', in *Weltbühne*, 33, 1962 | Günter Meißner: 'Werner Tübke', in *Weggefährten: 25 Künstler der DDR*, Dresden 1970 | *Werner Tübke*, catalogue, Galleria del Levante, Milan 1971 (text: Roberto Tassi) | *Werner Tübke*, catalogue, Studioausstellung, Nationalgalerie Berlin 1972 | Ullrich Kuhirt: 'Betrachtungen zum Werk des Malers Werner Tübke', In *Bildende Kunst*, 1, 1972 | Peter Sager: *Neue Formen des Realismus*, Cologne 1973; Catalogue, *Zeichnungen in der Kunst der DDR*, Kupferstichkabinett Dresden 1974 | *Werner Tübke*, catalogue, Dresden, Leipzig, Berlin 1974 (with complete list of paintings and bibliography) (text: Günter Meißner, Joachim Uhlitzsch) | Irma Emmrich: *Werner Tübke: Schöpfertum und Erbe*, Berlin 1976 | Henry Schumann: *Ateliergespräche*, Leipzig 1976 | Werner Tübke, catalogue, Galerie Arkade, Berlin 1977 (text: Harald Olbrich) | Catalogue, *documenta 6*, Kassel 1977 (text: Lothar Lang) | Renate Blau: '50. Geburtstag des Malers und Grafikers Werner Tübke', in *Bibliographische Kalenderblätter*, 21, 1979 (with bibliography) | *Werner Tübke, Malerei, Grafik, Zeichnung*, catalogue, Staatliche Galerie, Moritzburg Halle, and *Memorial of Peasants' War 'Panorama'*, Bad Frankenhausen 1979 (text: Hermann Raum) | Catalogue, Aachen Neue Galerie–Sammlung Ludwig 1979 | Günter Meißner: 'Werner Tübke', in *Künstler der DDR*, Dresden 1981 (with bibliography) | Peter M. Bode: 'Werner Tübke', in *Zeitvergleich – Malerei und Grafik in der DDR*, Hamburg 1982 (with list of exhibitions and bibliography) | 'Ich bin ein realistischer Maler – Gespräch mit Professor Werner Tübke', *Sonntag*, 21, 1982.

FRANK VOIGT:

First personal exhibition 1980, Galerie Comenius, Dresden.

Frank Voigt: *Malerei und Grafik*, pamphlet Galerie Comenius (text: Diether Schmidt) | *Wolfgang Petrovsky, Frank Voigt*, pamphlet, Galerie Nord, Dresden 1984 (text: Bernd Rosner).

Exhibition selected by David Elliott

Technical assistance from Carol Brown, Graham Halstead and Sarah Shalgosky

Prepared by the Centre for Art Exhibitions of the GDR and
toured in Great Britain by the Museum of Modern Art, Oxford

Museum of Modern Art, Oxford: 3 June–29 July 1984
Herbert Art Gallery, Coventry: 11 August–23 September 1984
City of Sheffield Art Galleries: 29 September–4 November 1984
The Hatton Art Gallery, Newcastle-upon-Tyne: 26 November 1984–19 January 1985
The Barbican Gallery, London: 13 February–31 March 1985

Cover illustrations
Werner Tübke **Three Women from Cefalu** 1983 (above)
Walter Libuda **Birth** 1980

Catalogue prepared by Gabriele Wittrin

Translated by Wilf Deckner

Designed by Richard Hollis

Photographs by
Monika Bernhardt, Dresden
Egon Beyer, Schöneiche
Viola Boden, Leipzig
Jürgen Buchhold, Freital
Walter Danz, Halle
Deutsche Fotothek, Dresden
Milan Nelken, Berlin
Christoph Sandig, Leipzig
Wolfgang Sommerfeld, Falkensee
Technical University Dresden, Film and Picture Service
Asmus Steuerlein, Dresden
The Centre for Art Exhibitions of the GDR
Elfriede Schönborn

Printed in Great Britain by Burgess & Son (Abingdon) Ltd

Published by the Museum of Modern Art, 30 Pembroke Street, Oxford OX1 1BP, England

© Museum of Modern Art, Oxford 1984

ISBN 0 905836 43 X

A list of all Museum of Modern Art catalogues in print
can be obtained from the Bookshop Manager
at the above address.

This exhibition was organised with the kind co-operation of
the Ministry of Culture of the GDR.
Financial assistance from the Visiting Arts Unit of Great Britain
is gratefully acknowledged.